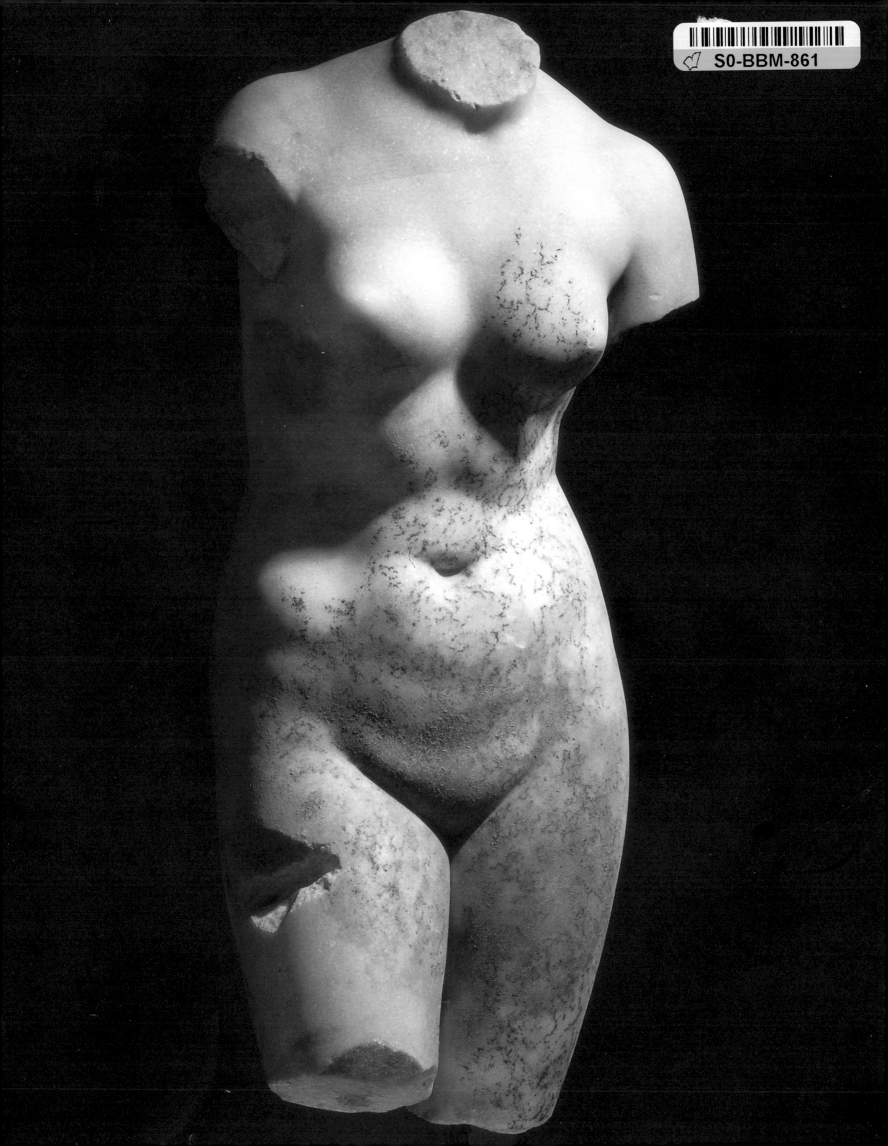

SOME WOMEN

INTRODUCTION BY JOAN DIDION

by MAPPLETHORPE

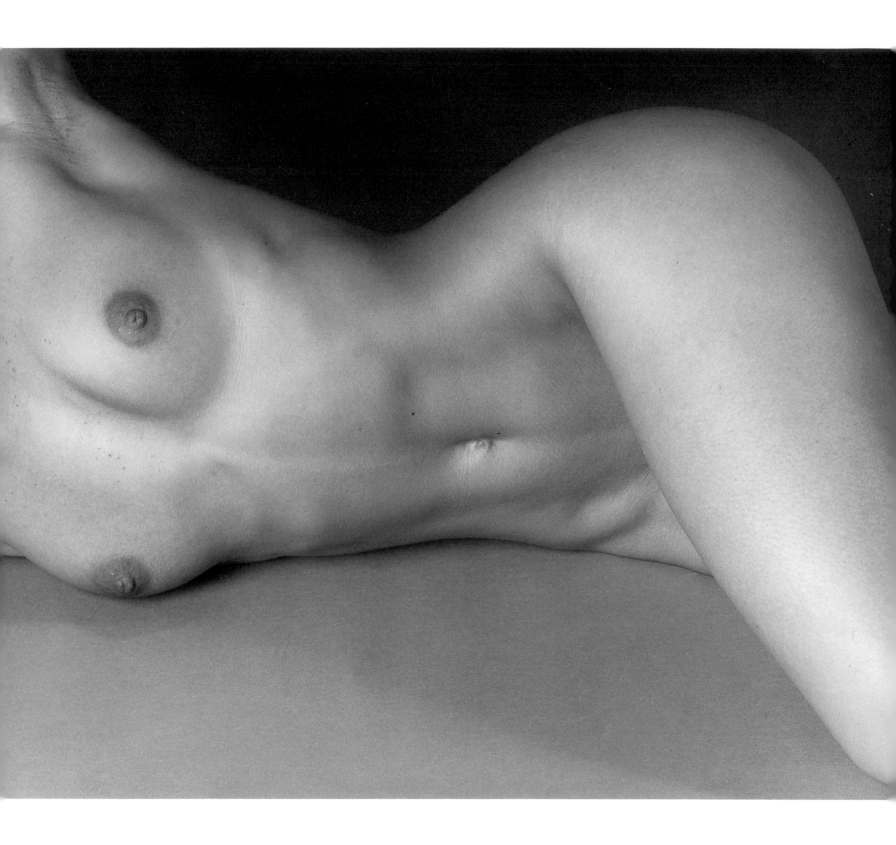

Bulfinch Press / Little, Brown & Company · Boston, Toronto, London

AN ANNOTATION

by JOAN DIDION

1

Some years ago I had a job, at *Vogue*, which involved going to photographers' studios and watching women being photographed. These were photographs meant not for the fashion but for the "feature" pages of *Vogue*, portraits of women celebrated for one reason or another, known (usually) because they were starring in a movie or appearing in a play or known (less often) because they had pioneered a vaccine or known (more often than we pretended) just because they were known. "Anything at all you're comfortable in," we were instructed to say if the subject ventured to ask what she should wear for the sitting; "We only want you to be yourself." We accepted without question, in other words, the traditional convention of the portrait, which was that somehow, somewhere, in the transaction between artist and subject, the "truth" about the latter would be revealed; that the photographer would penetrate and capture some "essence", some secret of personality or character not apparent to the naked eye.

In fact what occurred in these sittings, as in all portrait sittings, was a transaction of an entirely opposite kind: success was understood to depend on the extent to which the subject conspired, tacitly, to be not "herself" but whoever and whatever it was that the photographer wanted to see in the lens. Of those long mornings and afternoons in the studio (whether the studio was uptown or downtown, whether it belonged to Irving Penn or to Bert Stern or to Duane Michals or to one of a dozen other photographers then shooting feature for *Vogue*, it was referred to always as just "the studio", a generic workspace, a syntactical reflex left from the years when all *Vogue*'s contract photographers worked in the magazine's own studio) I recall mainly little tricks, small improvisations, the efforts required to ensure that the photographer was seeing what he wanted. I remember one sitting for which the lens was covered with black chiffon. I remember another during which, after the "anything at all" in which the subject had apparently believed herself comfortable had been seen in the Polaroids and declared not what was wanted, I lent the subject my own dress, and worked the rest of the sitting wrapped in my raincoat. Here, then, was an early lesson: there would be in each such photograph a "subject", the woman in the studio, and there would also be a subject, and the two would not necessarily intersect.

2

This business of the subject is tricky. Whether they are painters or photographers or composers or choreographers or for that matter writers, people whose work it is to make something out of nothing do not much like to talk about what they do or how they do it. They will talk quite freely about the technical tricks involved in what they do, about lighting and filters if they are photographers, about voice and tone and rhythm if they are writers,

but not about content. The attempt to analyse one's own work, which is to say to know one's subject, is seen as destructive. Superstition prevails, fear that the fragile unfinished something will shatter, vanish, revert to the nothing from which it was made. Jean Cocteau once described all such work as deriving from "a profound indolence, a somnolence in which we indulge ourselves like invalids who try to prolong dreams"; in dreams we do not analyse the action, or it vanishes. Gabriel García Márquez once spoke to the New York *Times* about the "bad luck" which would befall him were he to discuss the novel he was then writing; he meant of course that the novel would go away, lose its power to compel his imagination. I once knew I "had" a novel when it presented itself to me as an oil slick, with an iridescent surface; during the several years it took me to finish the novel I mentioned the oil slick to no one, afraid the talismanic hold the image had on me would fade, go flat, go away, like a dream told at breakfast. "If you say too much you lose some of that mystery," Robert Mapplethorpe once told a BBC interviewer who wanted to talk about his work. "You want to be able to pick up on the magic of the moment. That's the rush of doing photography. You don't know why it's happening but it's happening."

3

One question: If Robert Mapplethorpe's "subjects" here are women, what then is his subject?

One answer: His subject is the same as it was when his "subjects" were the men in leather, or the flowers, or the *Coral Sea* on a low horizon. *You don't know why it's happening but it's happening.* "I was a Catholic boy," he also told the BBC. "I went to church every Sunday. The way I arrange things is very Catholic. It's always been that way when I put things together. Very symmetrical."

4

Of the sixty-some women who appear in these pages most are well known, figures of considerable celebrity or fashion or achievement. There are models and there are actresses. There are singers, dancers, choreographers; makers of art and dealers in art. Most are New York women, with the familiar New York edge. Most are conventionally "pretty", even "beautiful", or rendered so not only by the artifices of light and makeup but by the way they present themselves to the camera: they are professional women, performers before the camera. They are women who know how to make their way in the world. They are women who know a lot of things, and what they know does not, on the evidence, encourage certainty. Some meet the camera here with closed eyes, as in a carnal swoon, or Victorian faint. Others confront it so directly as to seem startled into a fleeting madness; these would seem to be inhabitants of a world in which survival depends on the ability to seduce, beguile, conspire, deceive. *Sing for your supper*, something in these photographs tells us, *and you'll get breakfast.*

Songbirds always eat: this is not a "modern" idea, nor do the women in these pages present themselves to us as modern women. There are the familiar nineteenth-century images of domination and submission, the erotic discomforts of straps and leather and five-inch heels, of shoes that cause the wearer's flesh to wrinkle at the instep. There are doomed virgins here (downcast eyes, clasped hands), and intimations of mortality, skin like marble, faces like masques, a supernatural radiance, the phosphorescent glow we sometimes attribute to angels, and to decaying flesh.

The idealization here is never of the present. Mapplethorpe photographs meant to sell bathing suits suggest not the athleticism associated with an idealized present, not freedom of movement at all, but bondage,

and spanking, the sexual dreams of imperial England. The familiar face of Grace Jones, as photographed by Mapplethorpe, suggests not the androgynous future for which it has come to stand but the nineteenth-century passion for the exotic, the romance with Africa, with Egypt. A Mapplethorpe fashion photograph for *Interview*, the naked black "Thomas" dancing with the spectrally white "Dovanna", suggests classical ballet, the pas de deux in which the betrayer courts the betrayed, back from the grave, the prima ballerina from the dance of the shades.

Even the little girls in a Mapplethorpe photograph are Victorian, not children in the modern sense but sentient beings, creatures with barrettes and bunnies but nonetheless grave with responsibility; small adults, who gaze at us with the utter clarity of what they know and do not yet know. Perversely, of all these women, only Yoko Ono presents herself as "modern", entirely in charge of herself, a woman who has negotiated the demands of sex and celebrity to appear before us as a middleaged survivor, with sensible lapels, clear eyes, blown hair. There is something interesting in all this, and willful, and the will is not that of the "subjects".

5

There was always about Robert Mapplethorpe an astonishing convergence of quite traditional romantic impulses. There was the romance of the apparently unconventional. There was the romance of art for its own sake. There was the willingness to test the outer reaches of the possible, to explore the "interesting" ("I just thought it would be an interesting idea, having a ring through your tit," he told the BBC about the early film "Robert Having His Nipple Pierced"), the romance of the edge. There was the romance of the Catholic boy from the lower-middle class reaches of Queens ("It wasn't what I wanted," he once said about that) who came to the city and broke on through to the other side, reinvented himself as a Rimbaud of the baths.

That romantic agony should have been revived as the downtown style in the greatest bourgeois city in the modern world at the moment of its decline was, in any historical sense, predictable, and yet Robert Mapplethorpe's work has often been seen as an aesthetic sport, so entirely outside any historical or social context, and so "new", as to resist interpretation. This "newness" has in fact become so fixed an idea about Mapplethorpe that we tend to overlook the source of his strength, which derived, from the beginning, less from the shock of the new than from the shock of the old, from the rather unnerving novelty of exposure to a fixed moral universe. There was always in his work the tension, even the struggle, between light and dark. There was the exaltation of powerlessness. There was the seductiveness of death, the fantasy of crucifixion.

There was, above all, the perilous imposition of order on chaos, of classical form on unthinkable images. *It's always been that way when I put things together. Very symmetrical.* "I don't like that particular word, 'shocking'," Robert Mapplethorpe told *ArtNews* in late 1988, when he was struggling with illness and asked one more time to discuss the famous leather photographs. "I'm looking for the unexpected. I'm looking for things I've never seen before. But I have trouble with the word 'shocking' because I'm not really shocked by anything...I was in a position to take those pictures. I felt an obligation to do them." This is the voice of someone whose subject was finally that very symmetry with which he himself had arranged things.

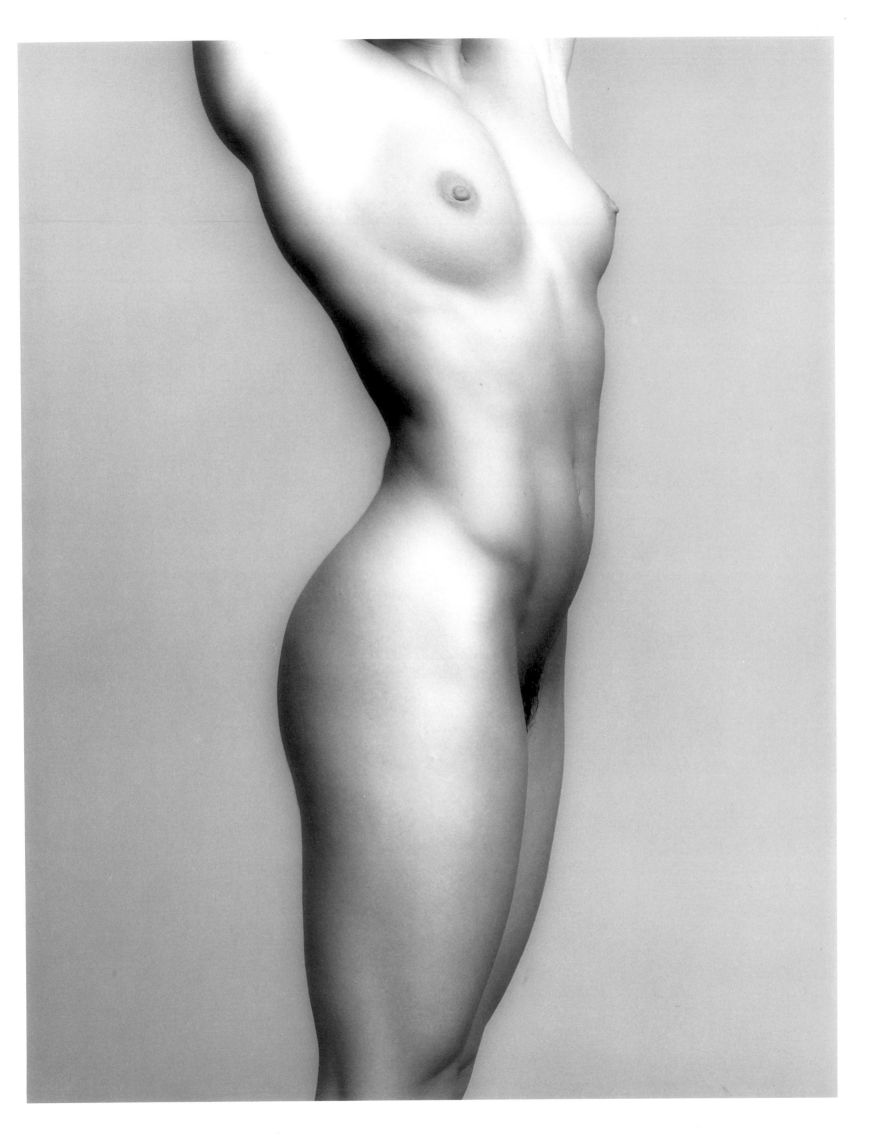

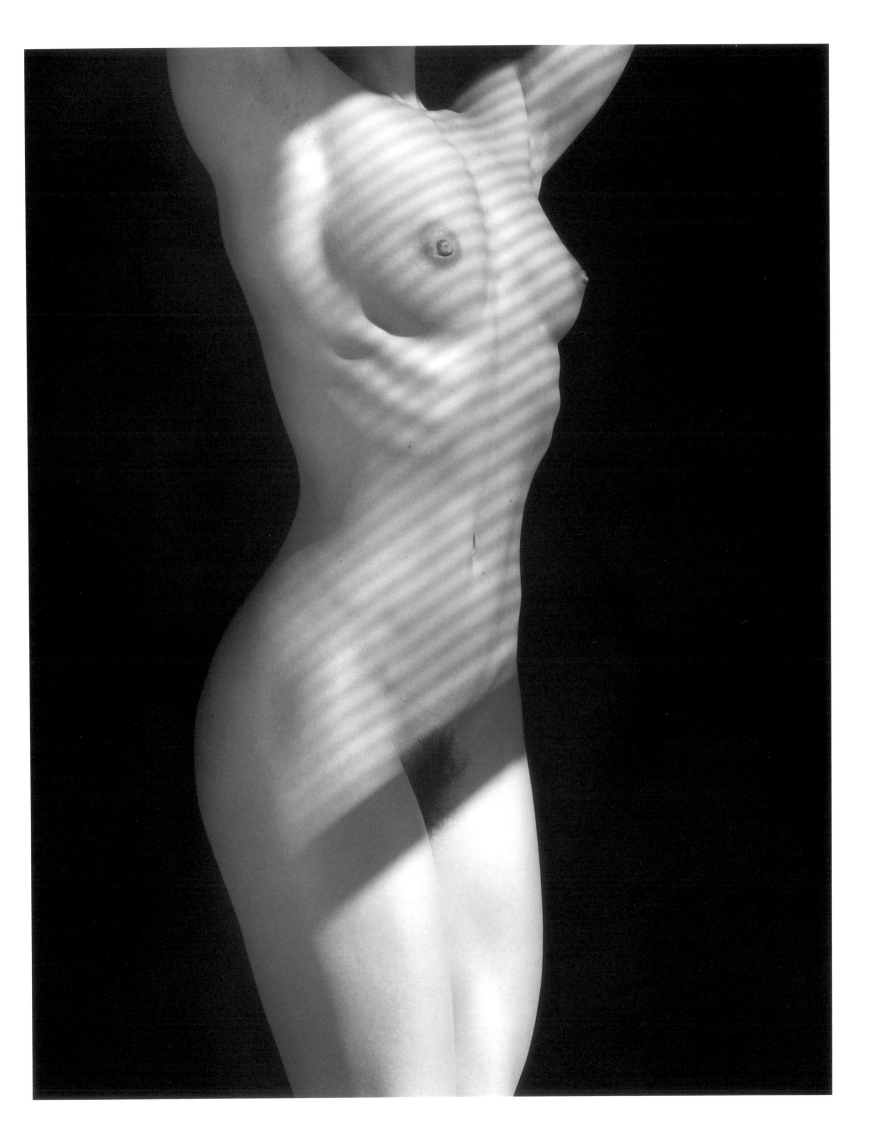

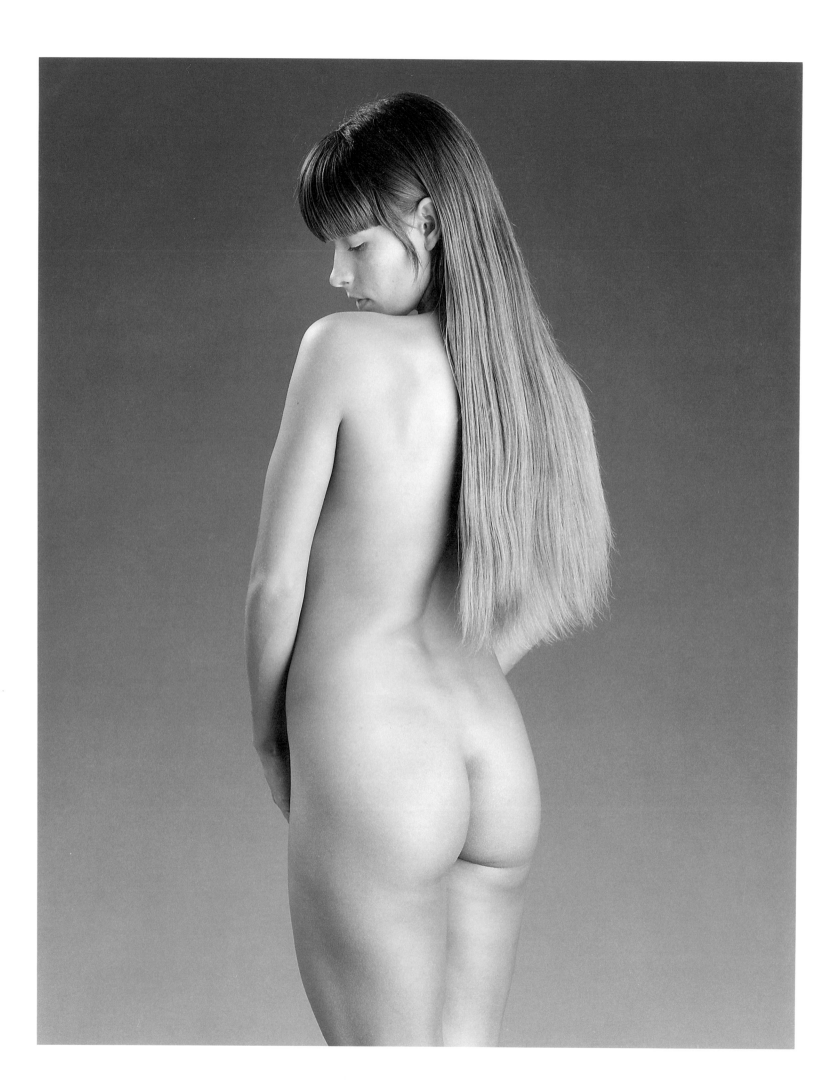

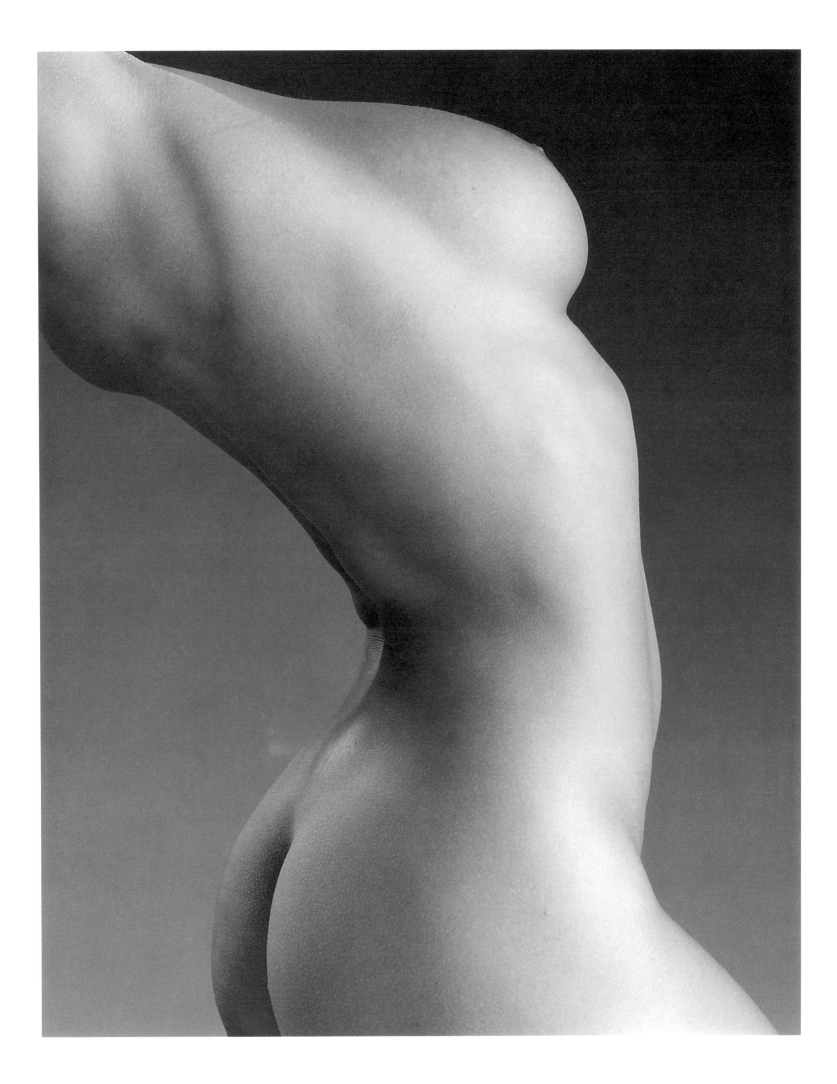

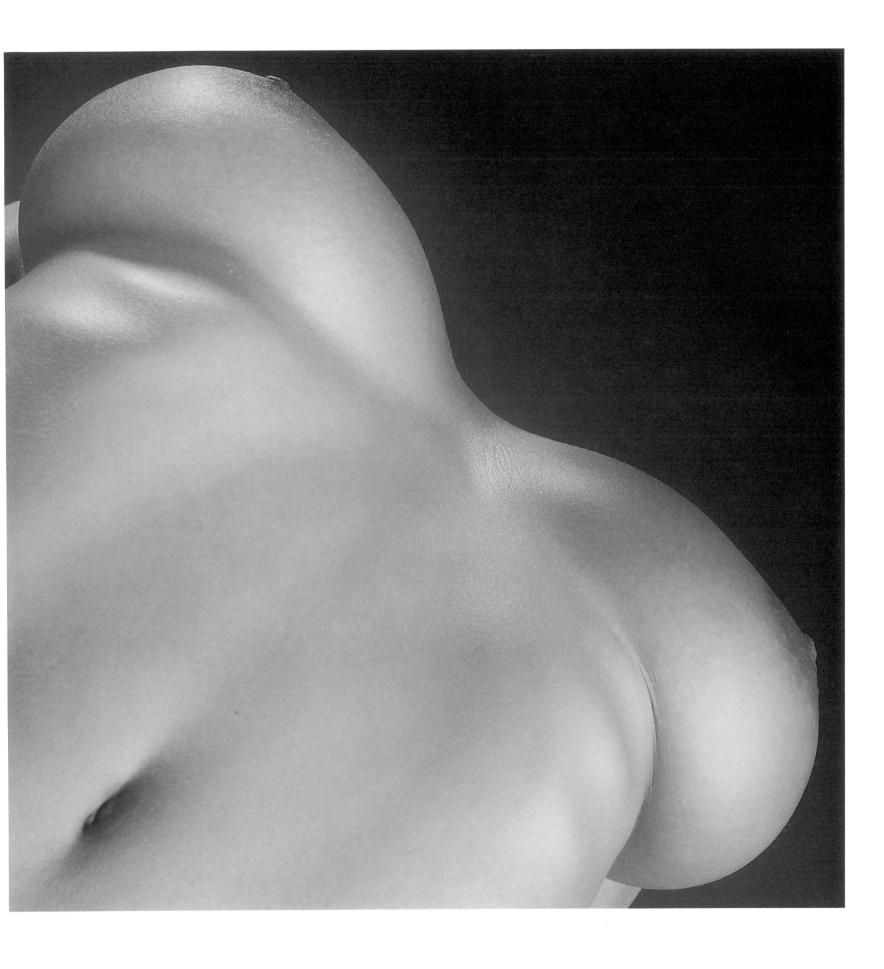

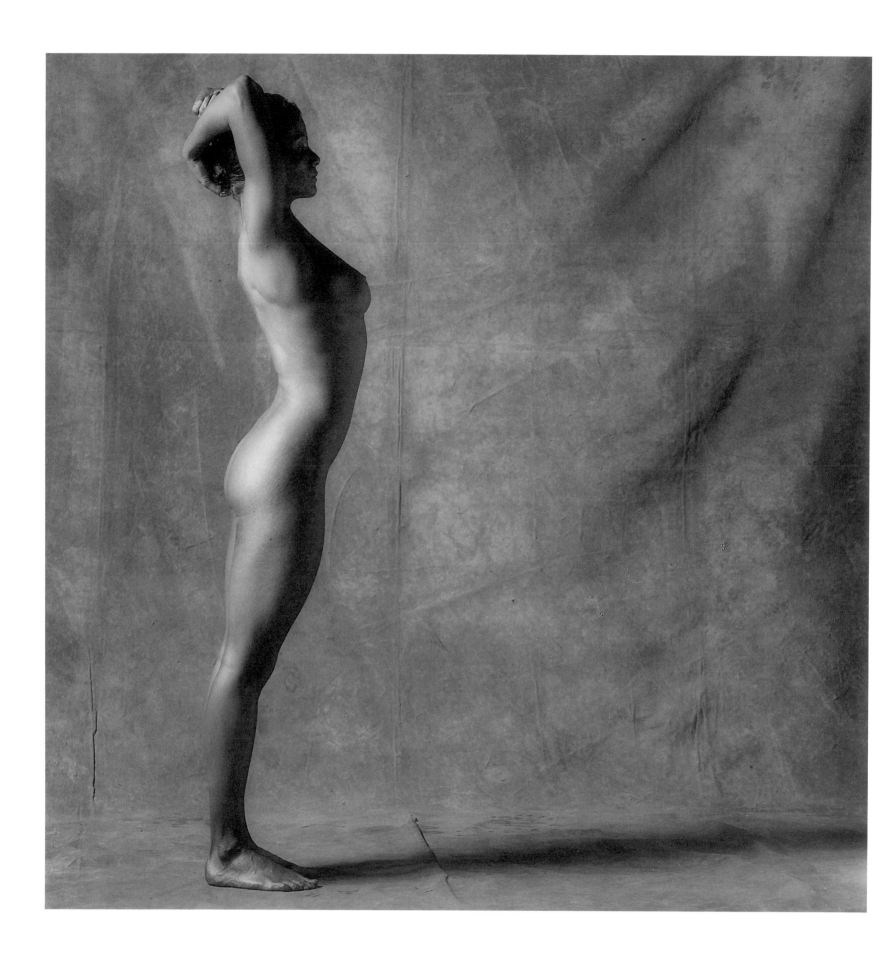

16

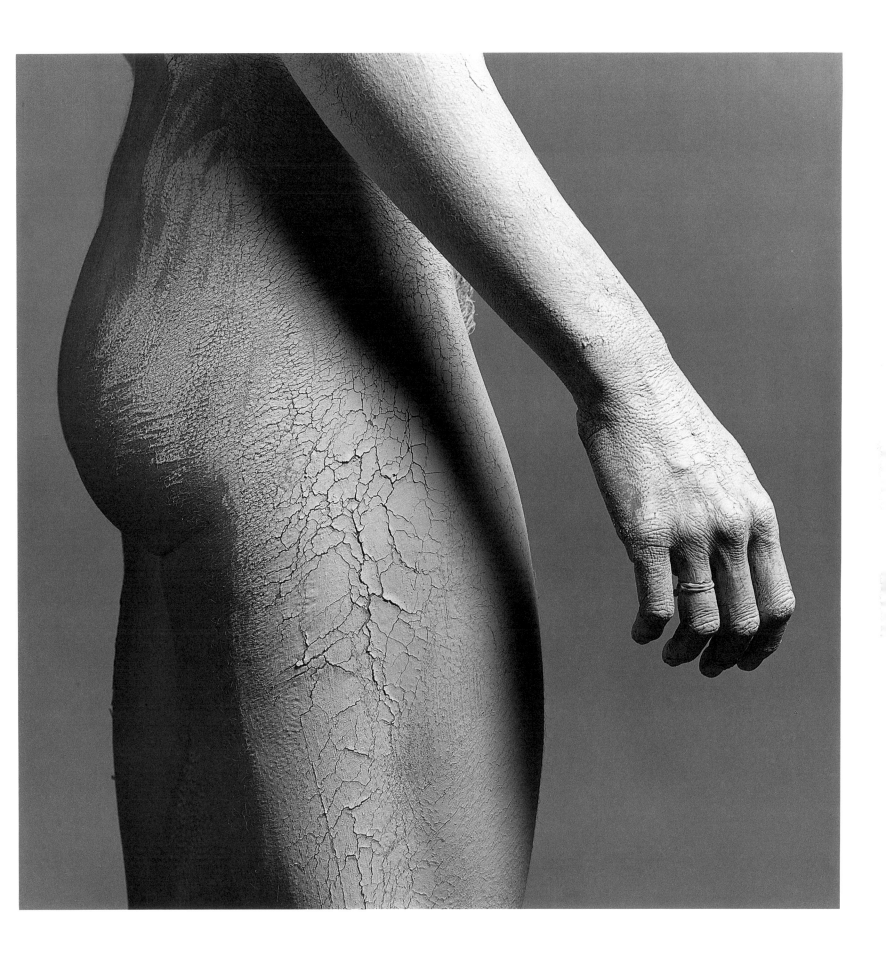

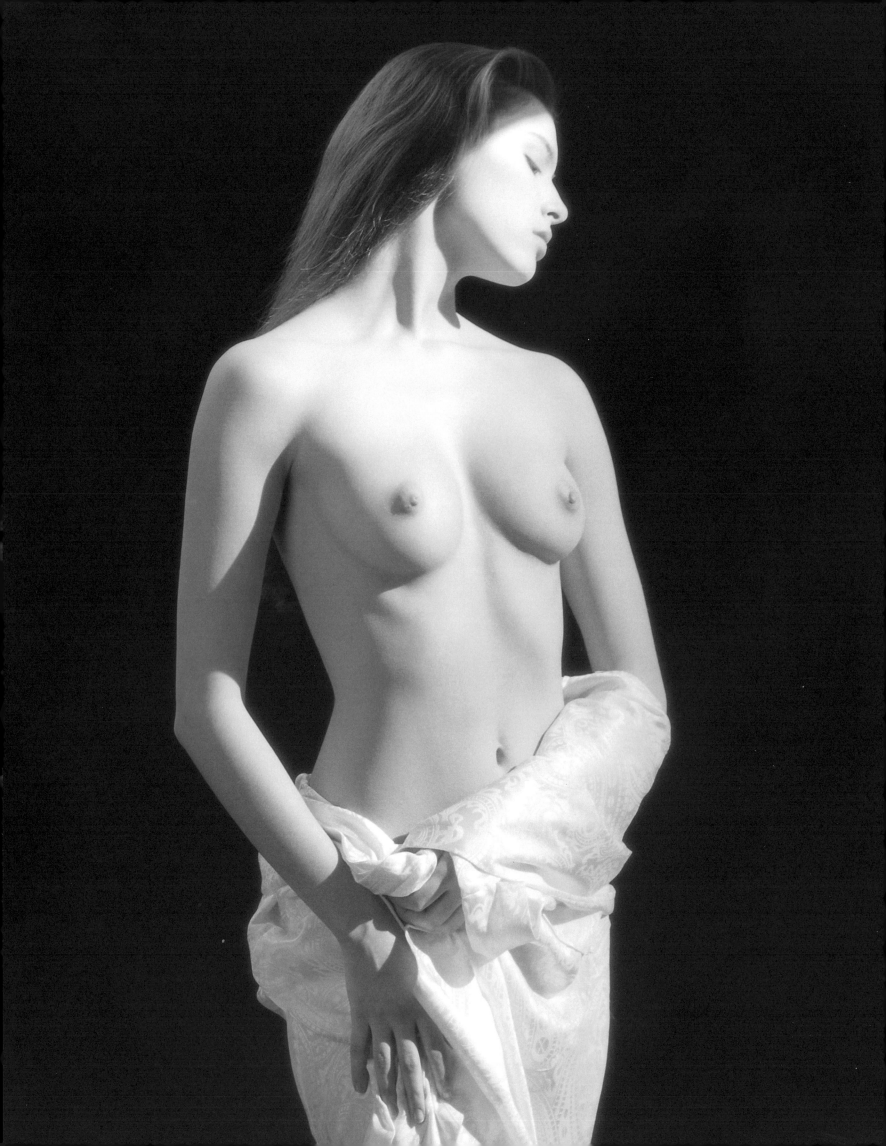

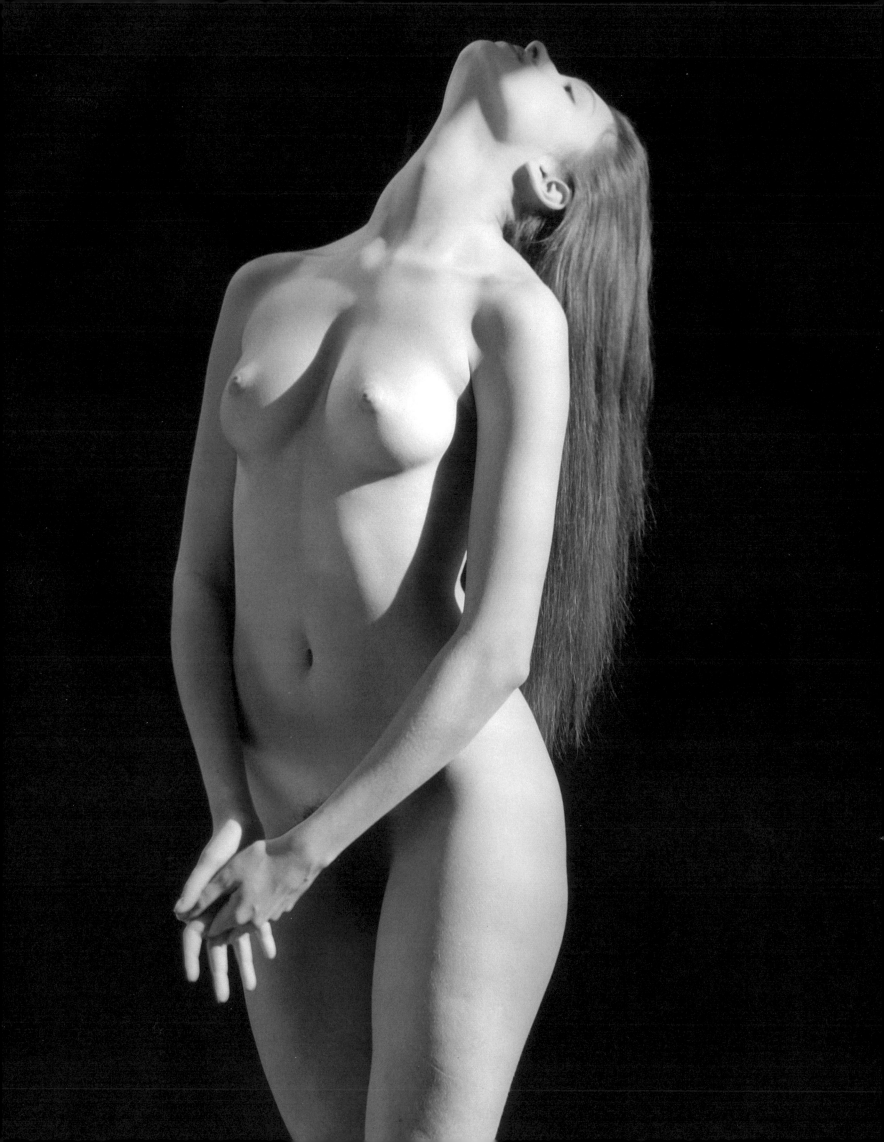

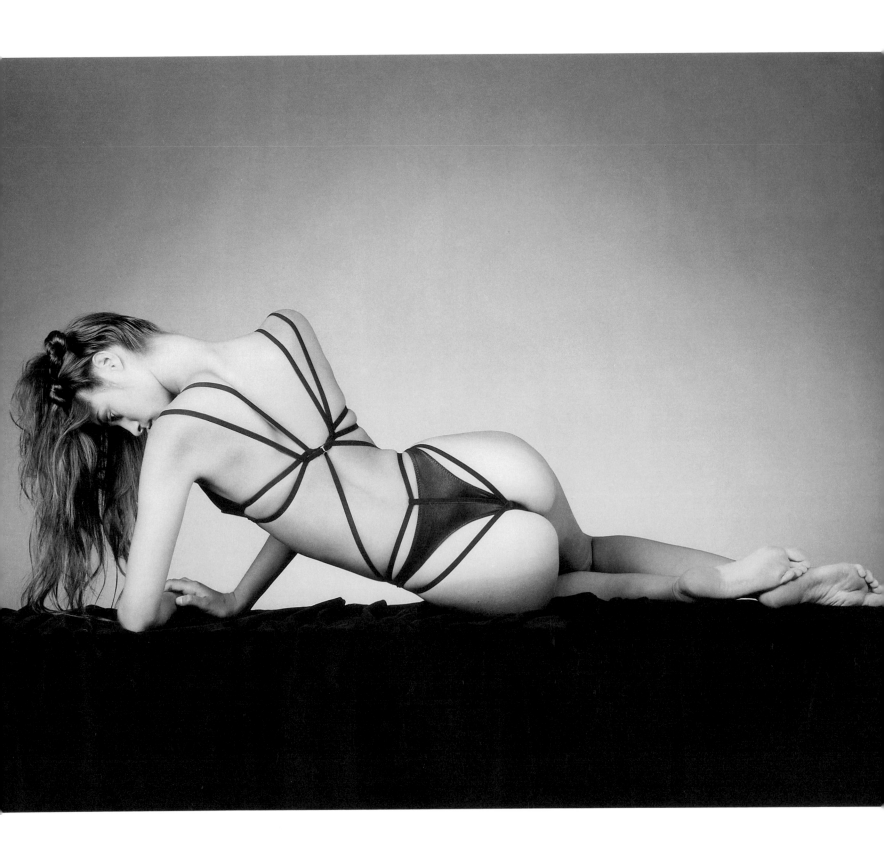

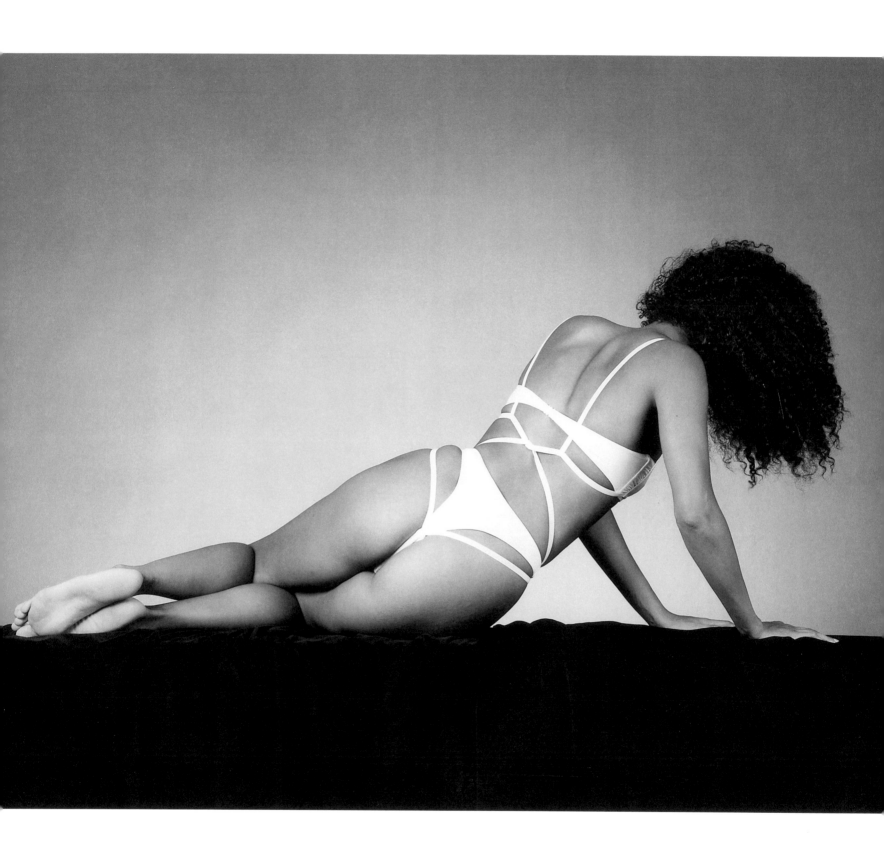

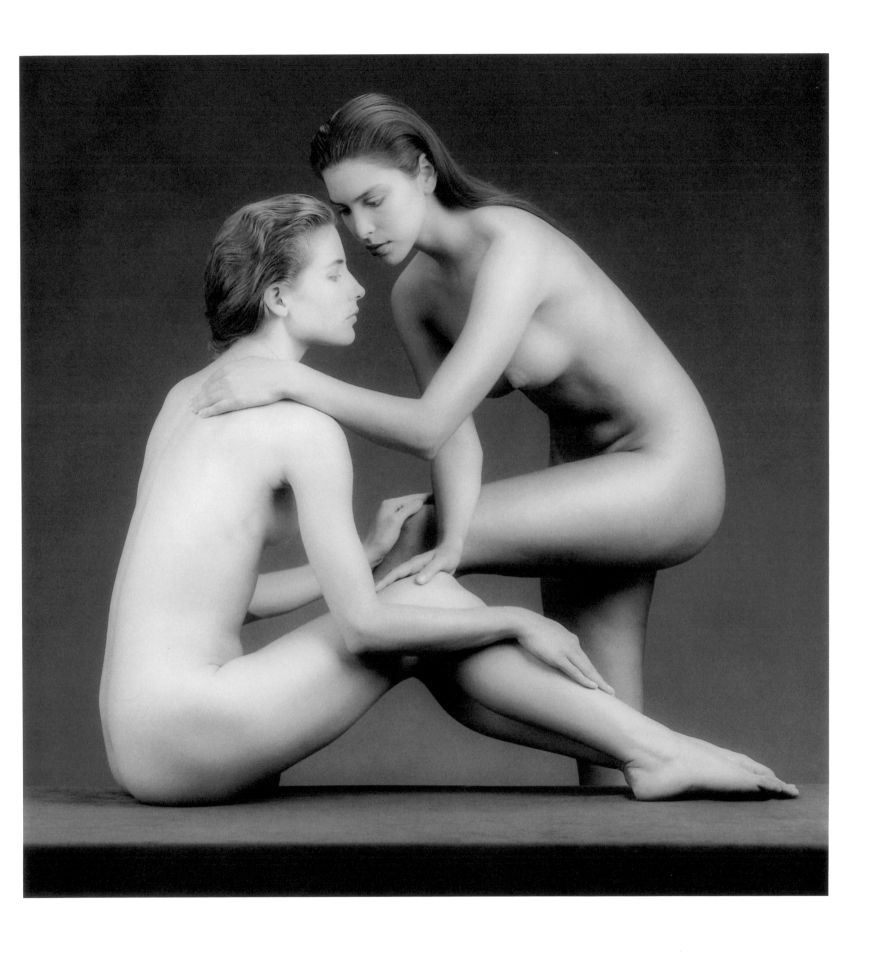

24

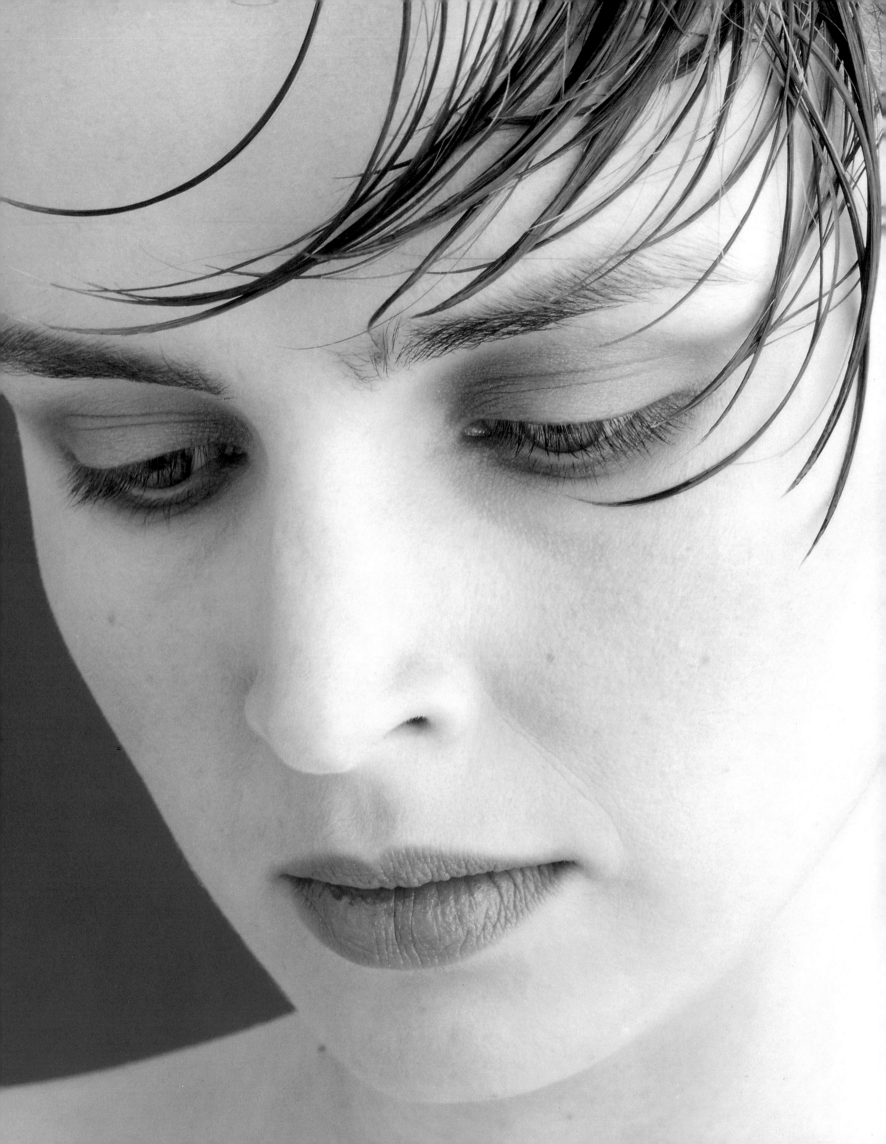

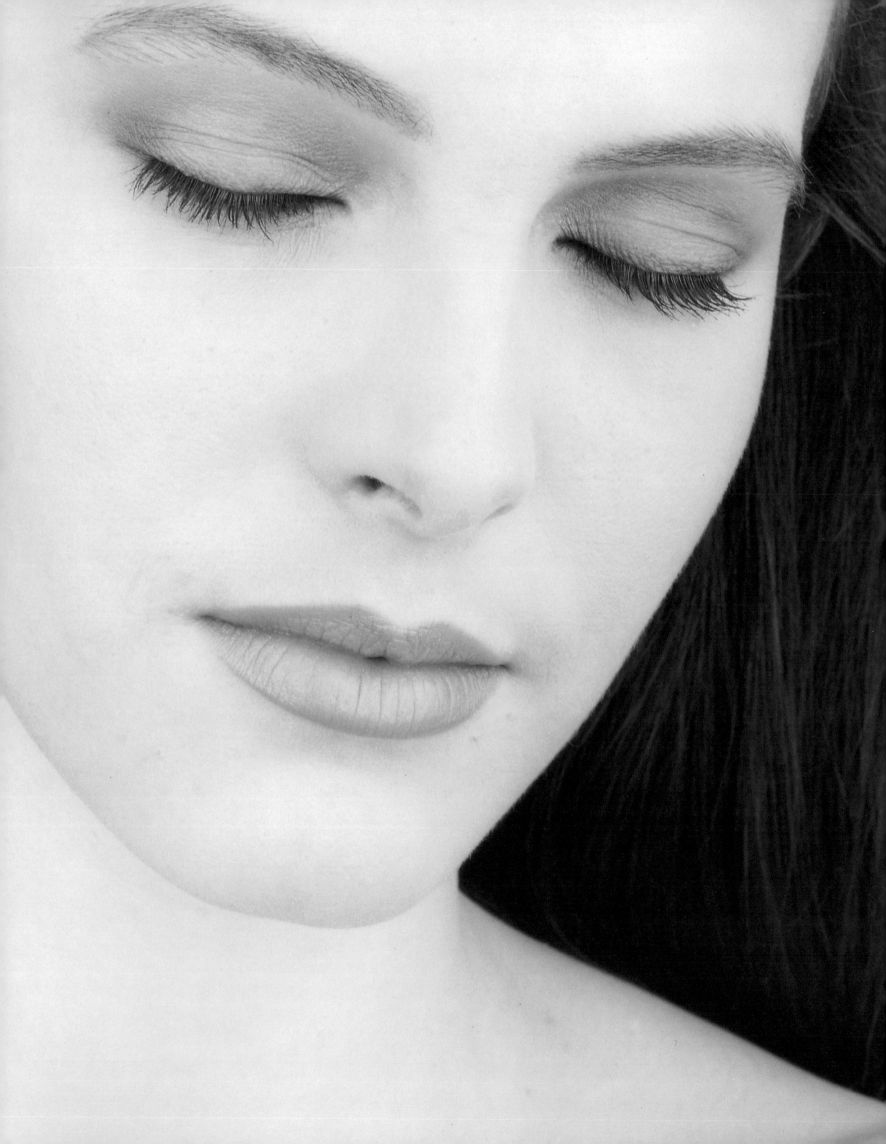

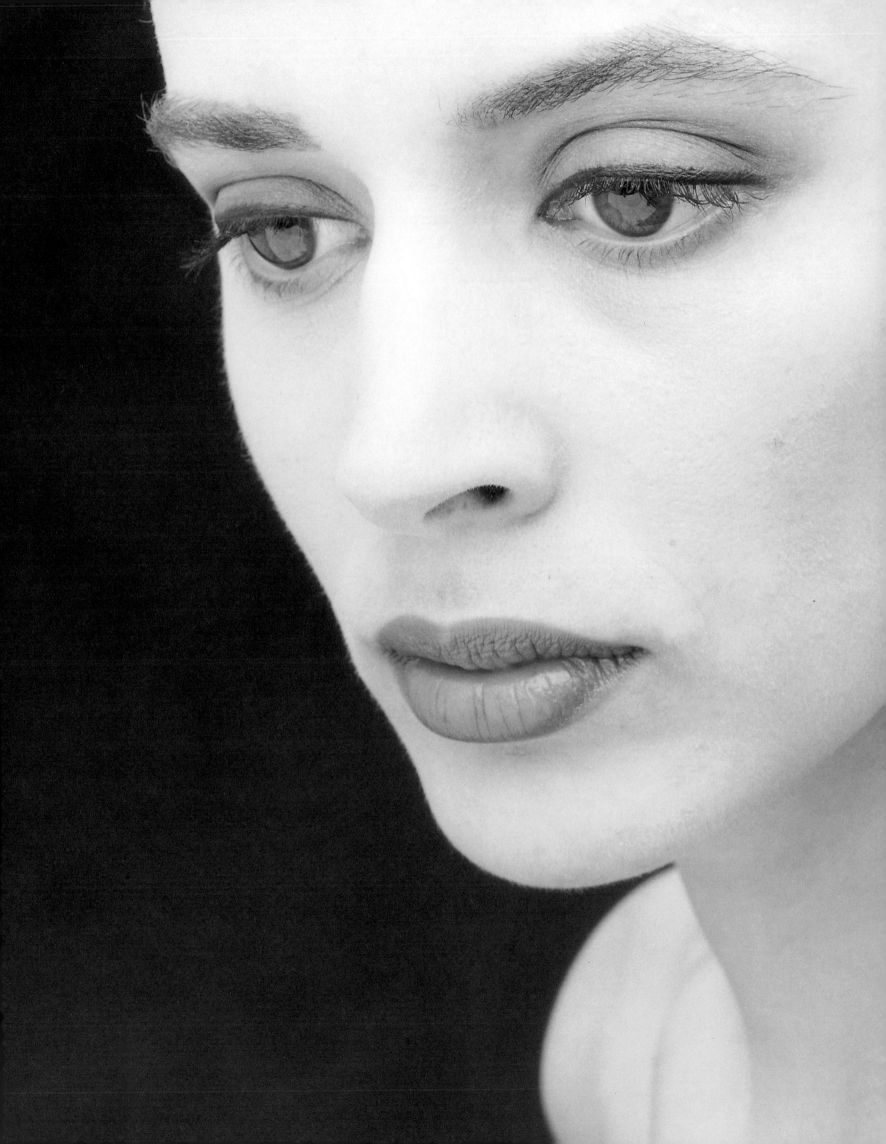

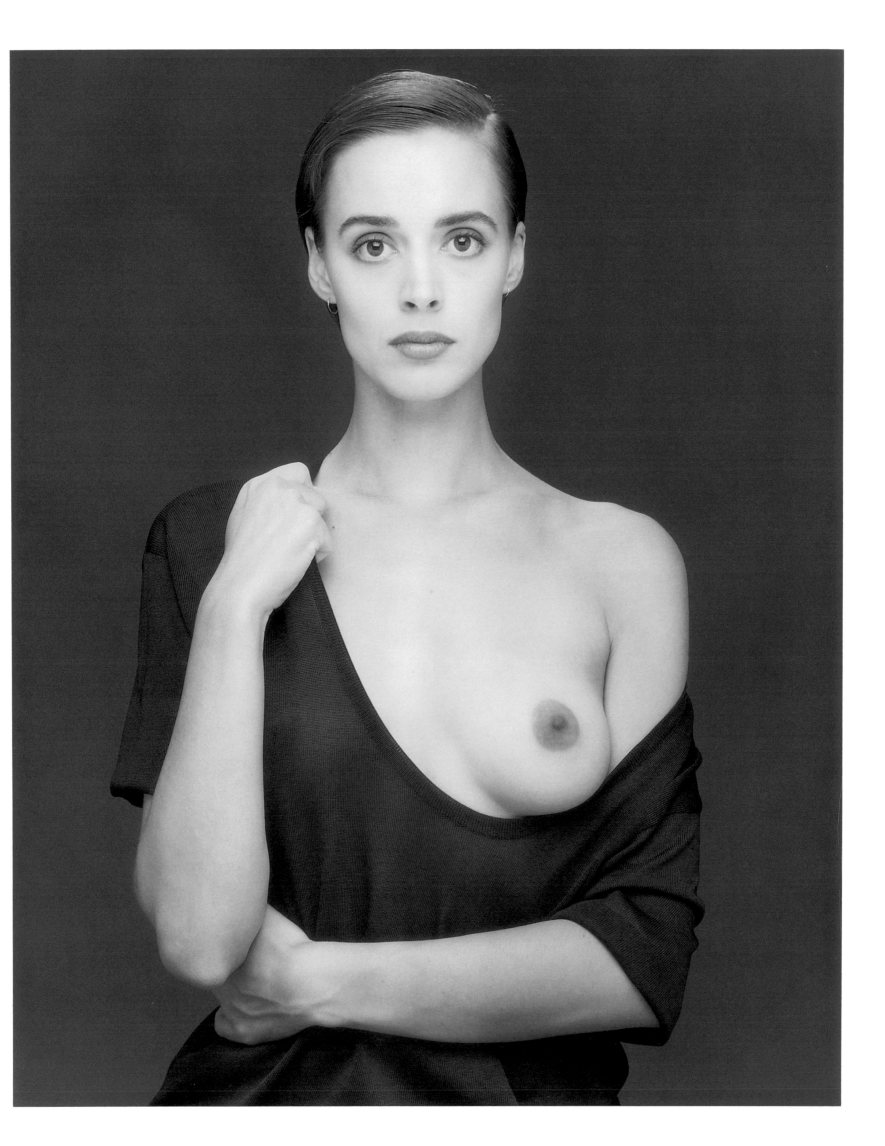

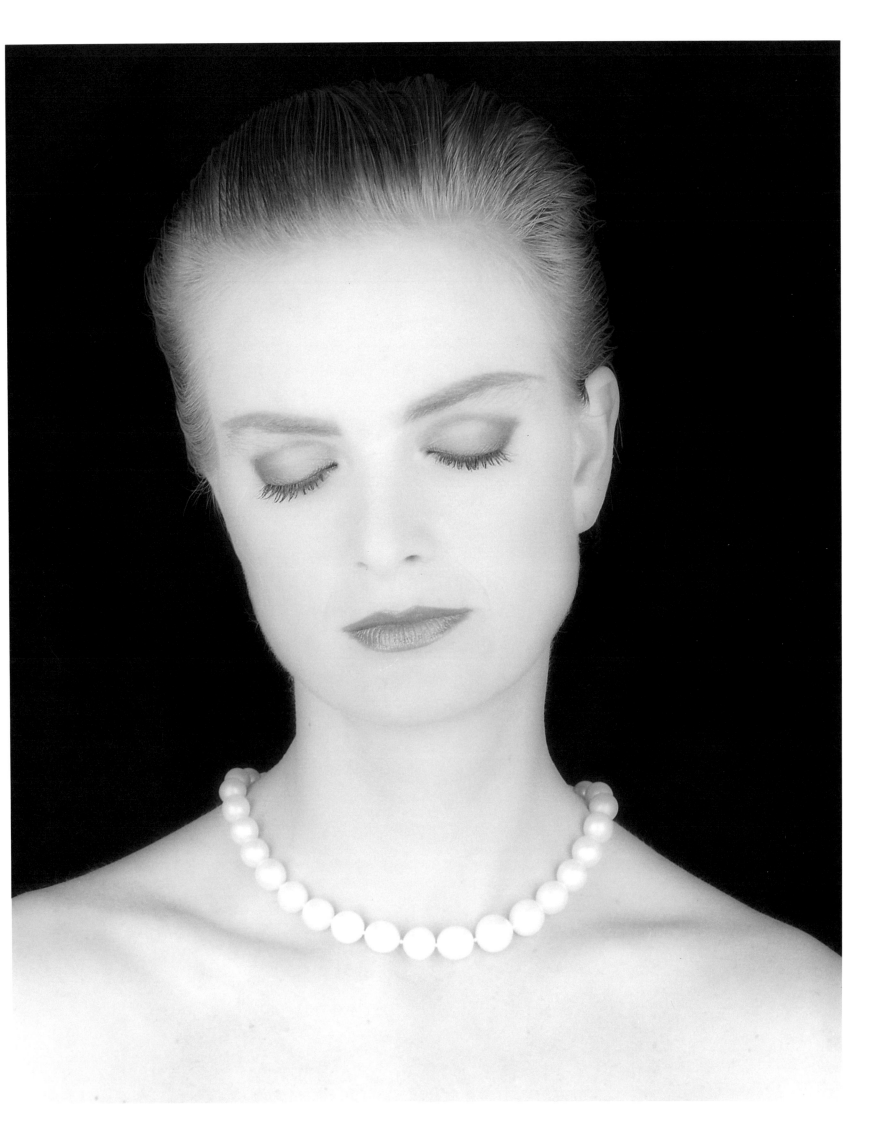

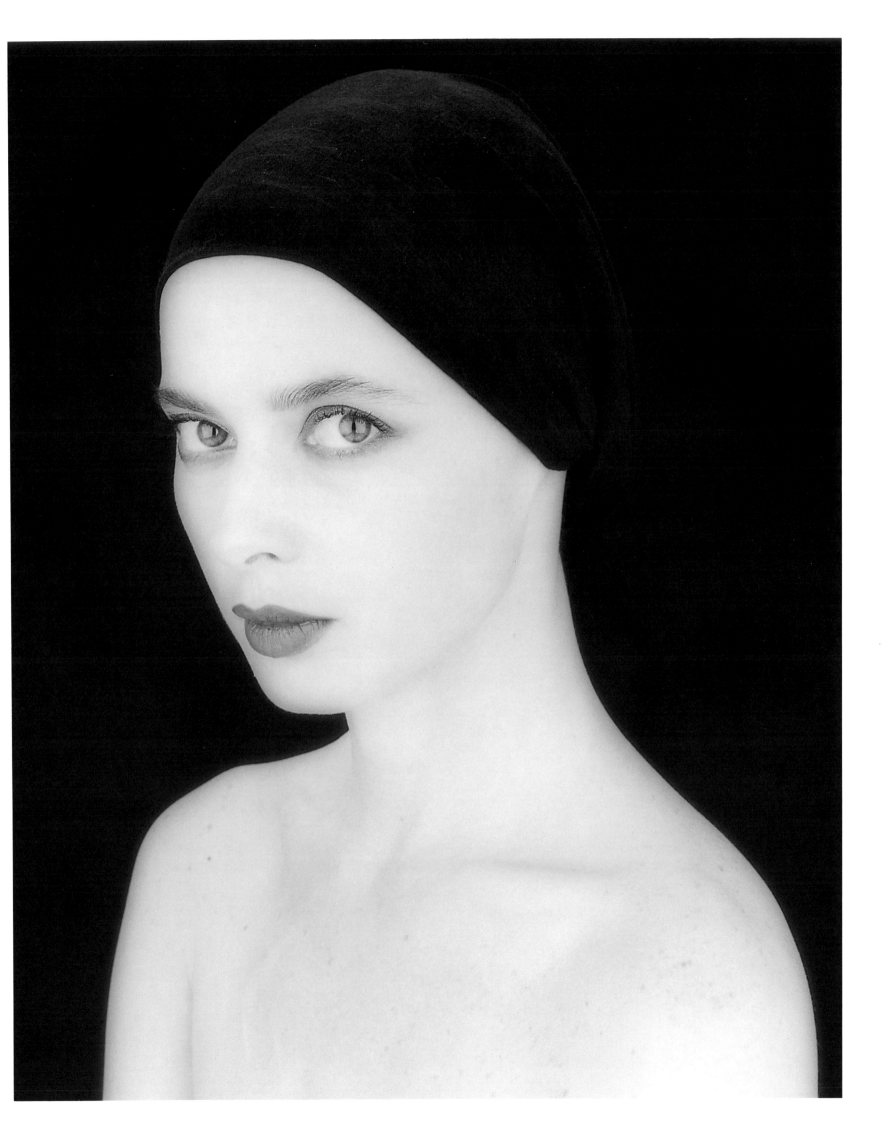

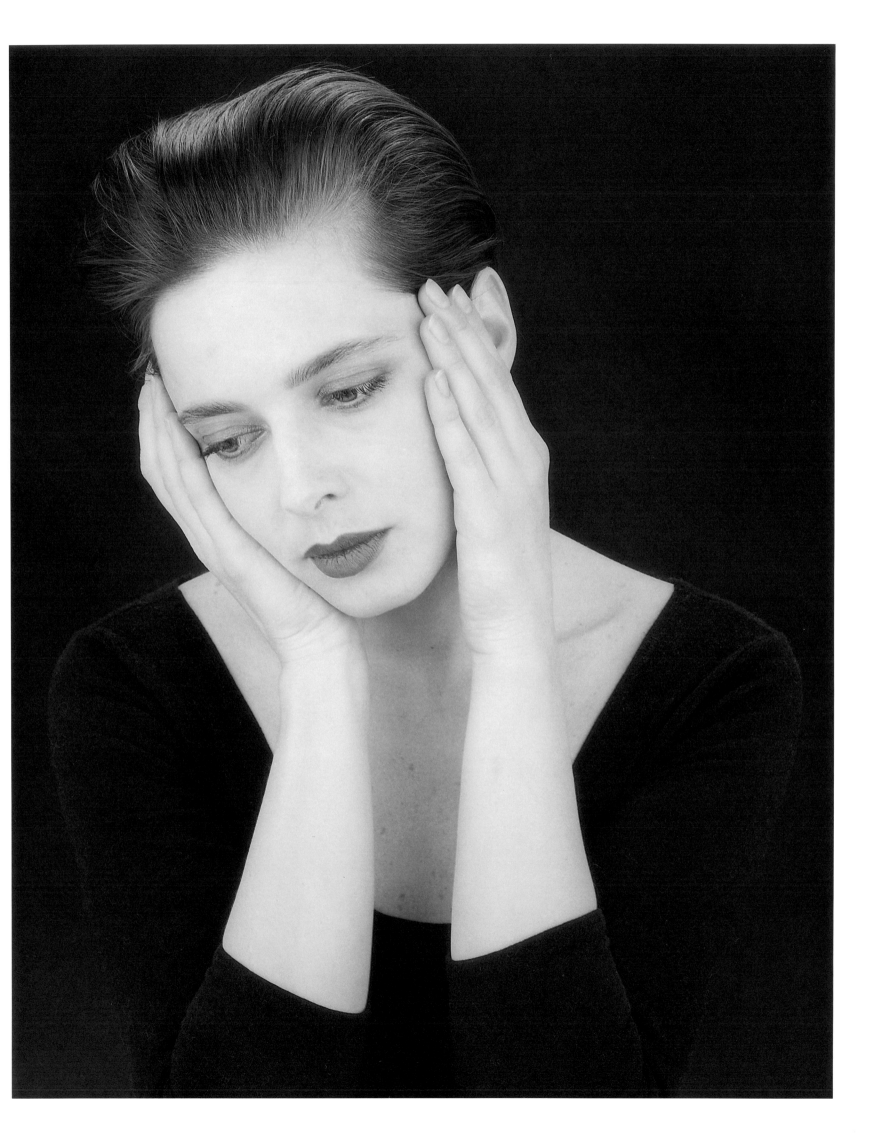

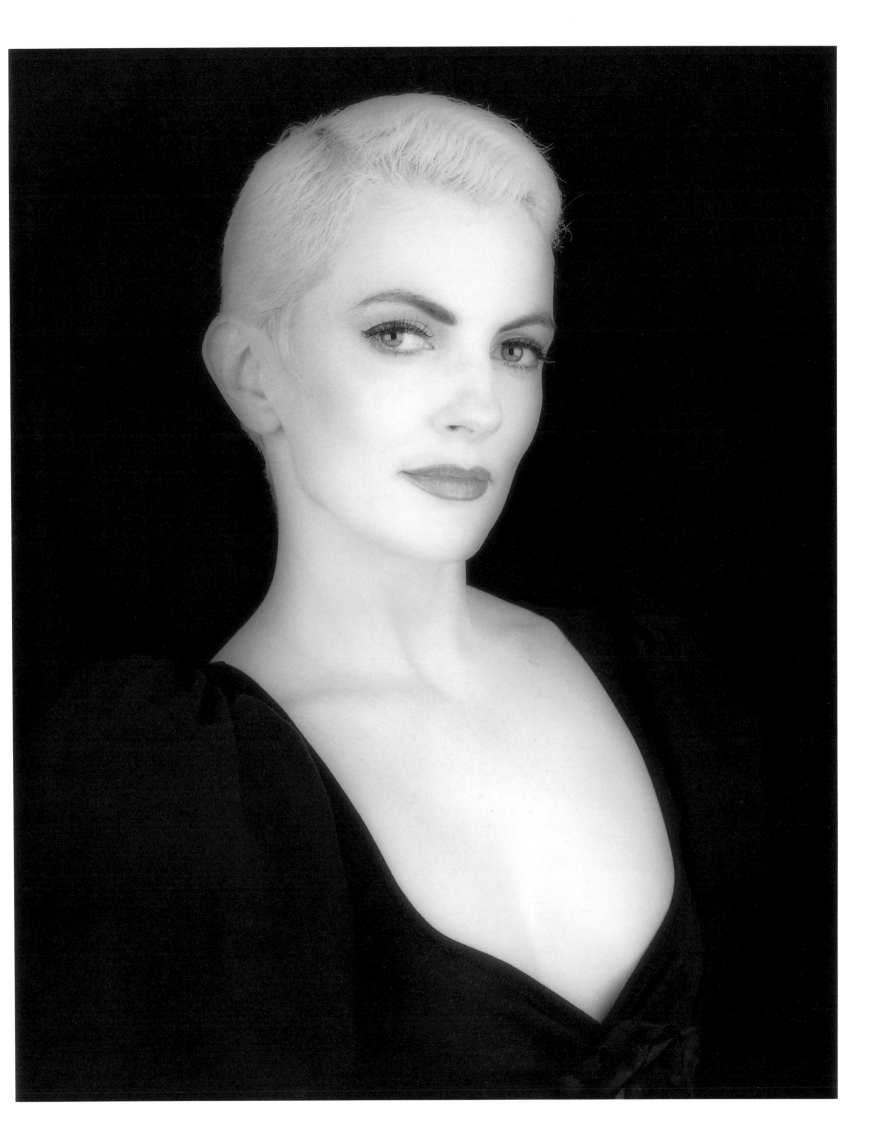

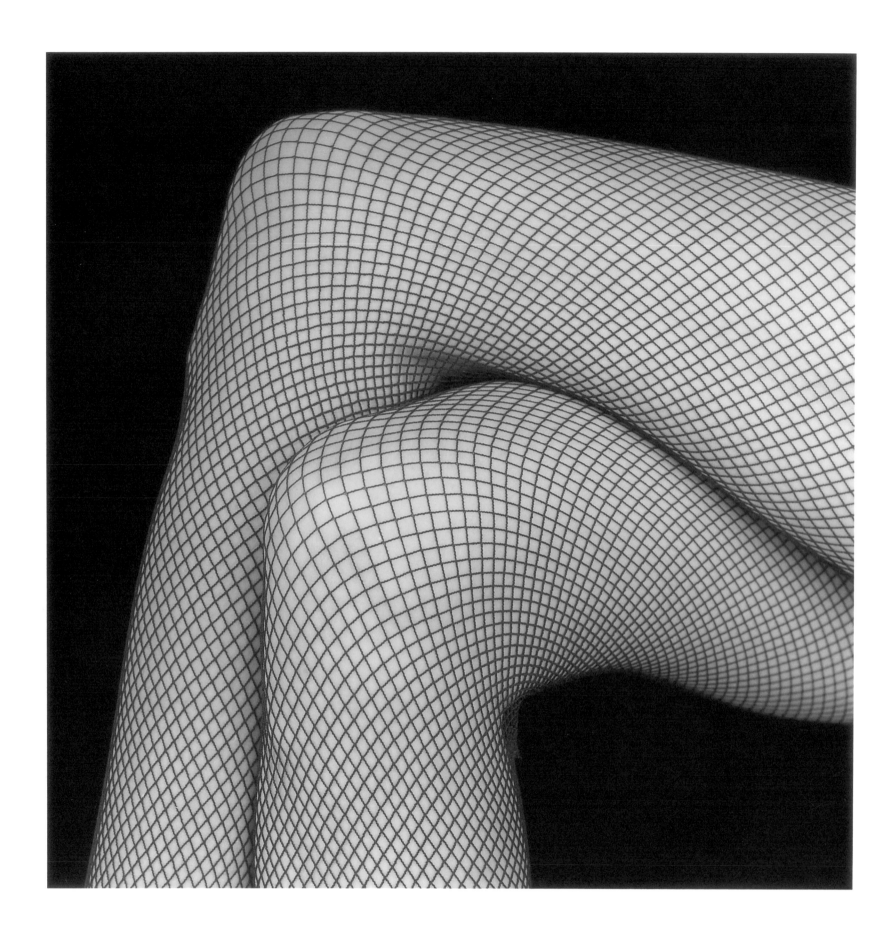

38

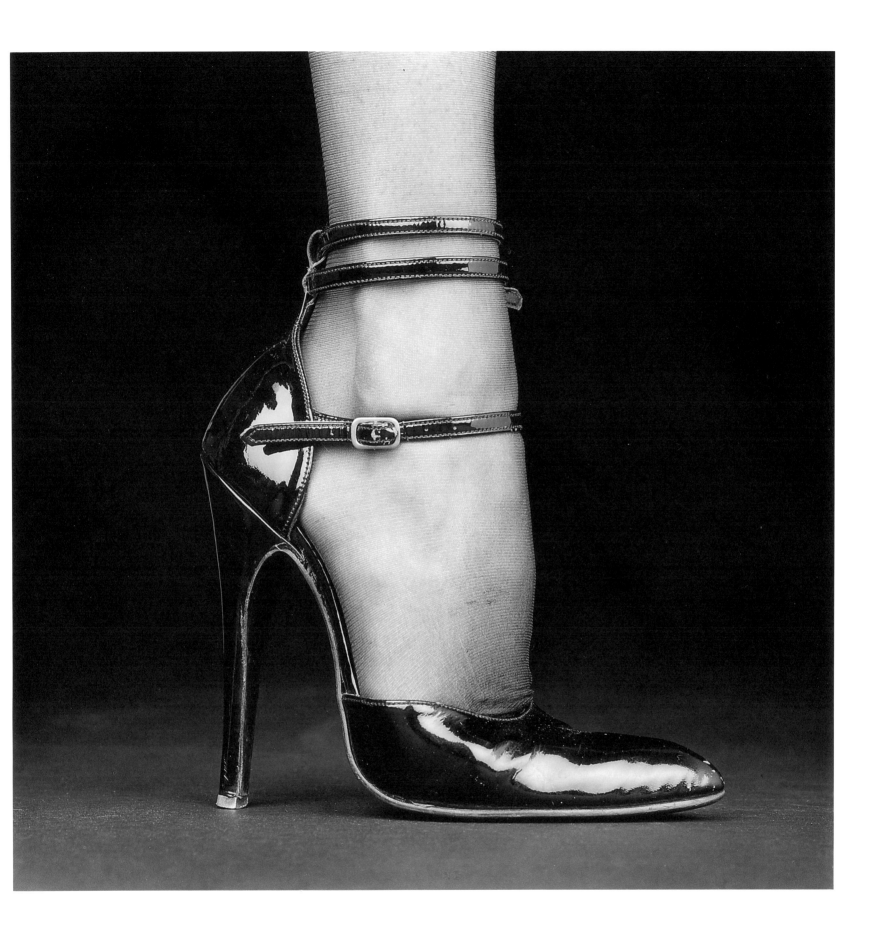

39

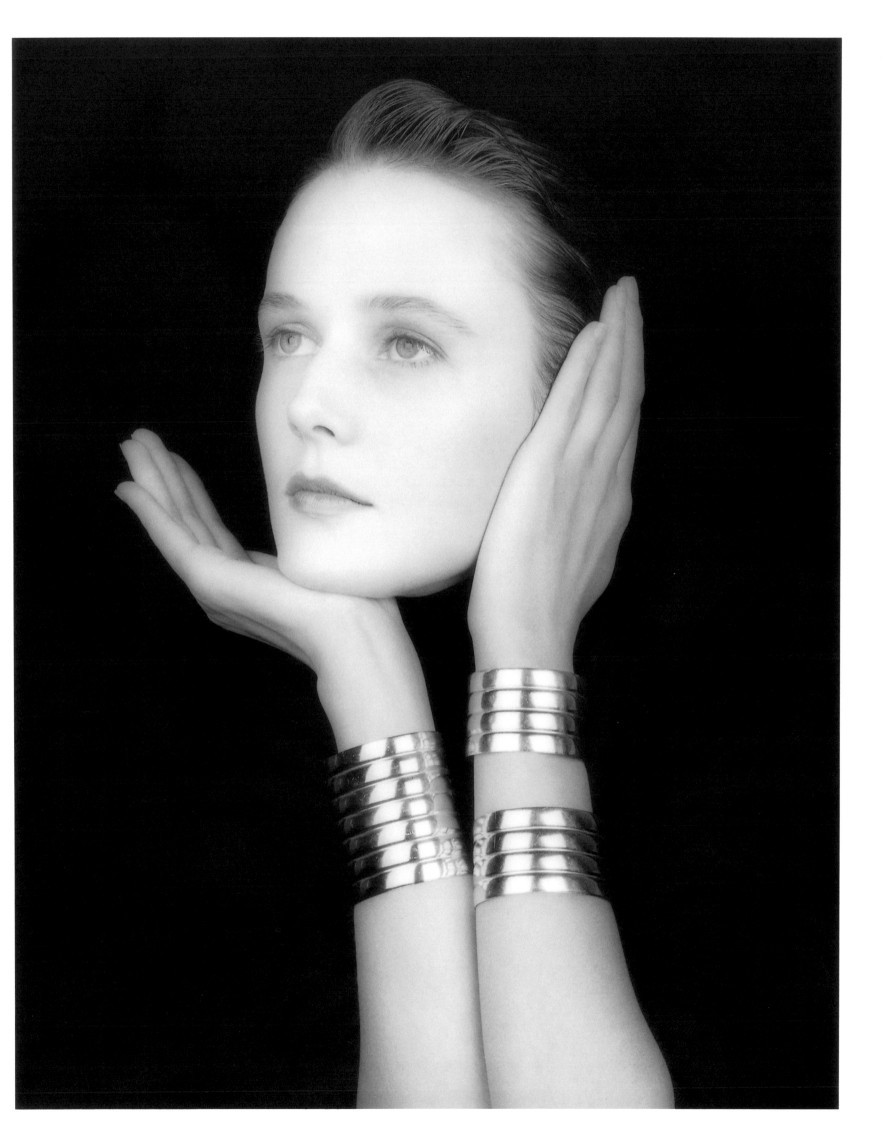

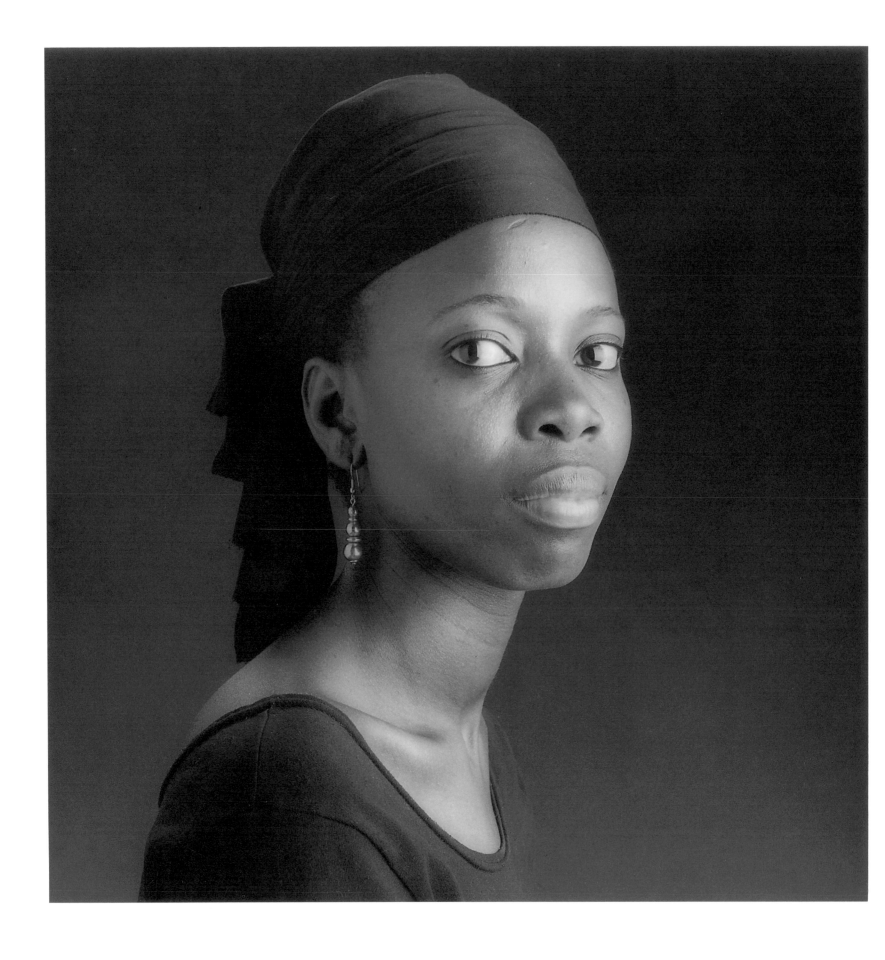

42

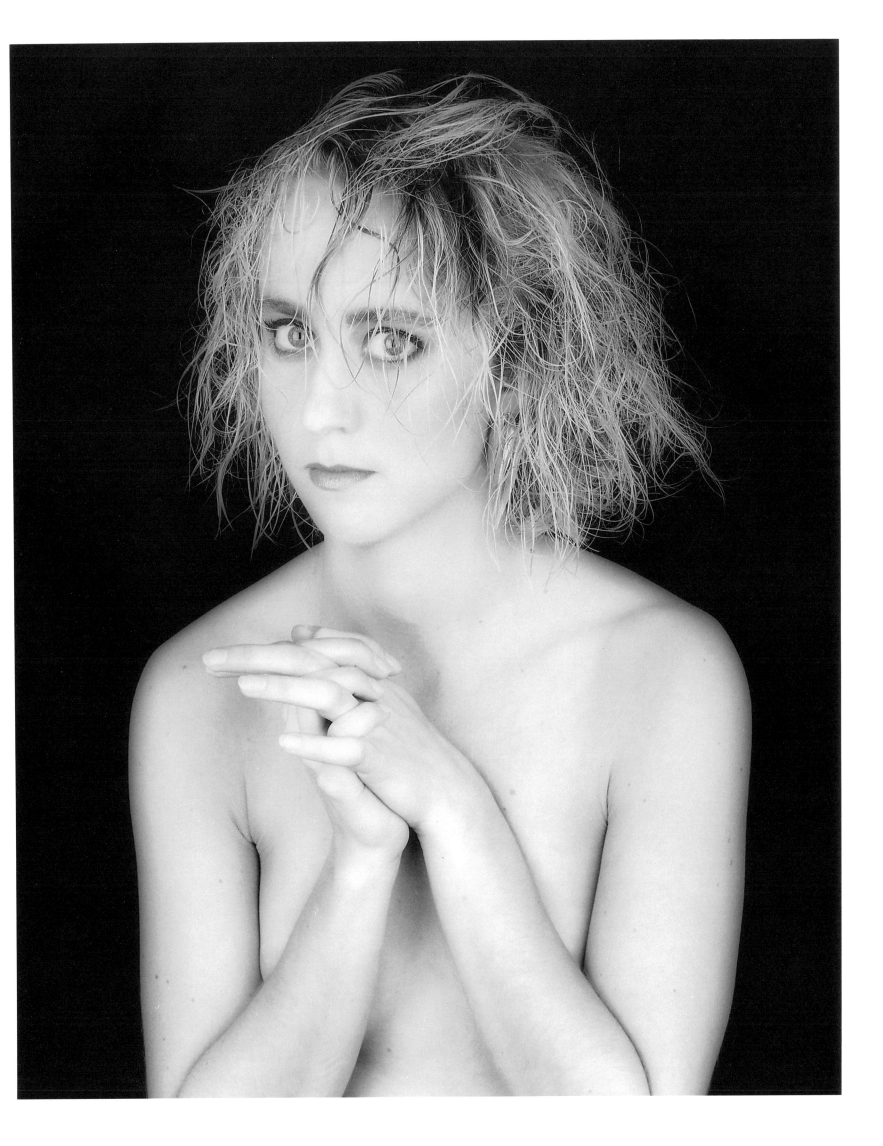

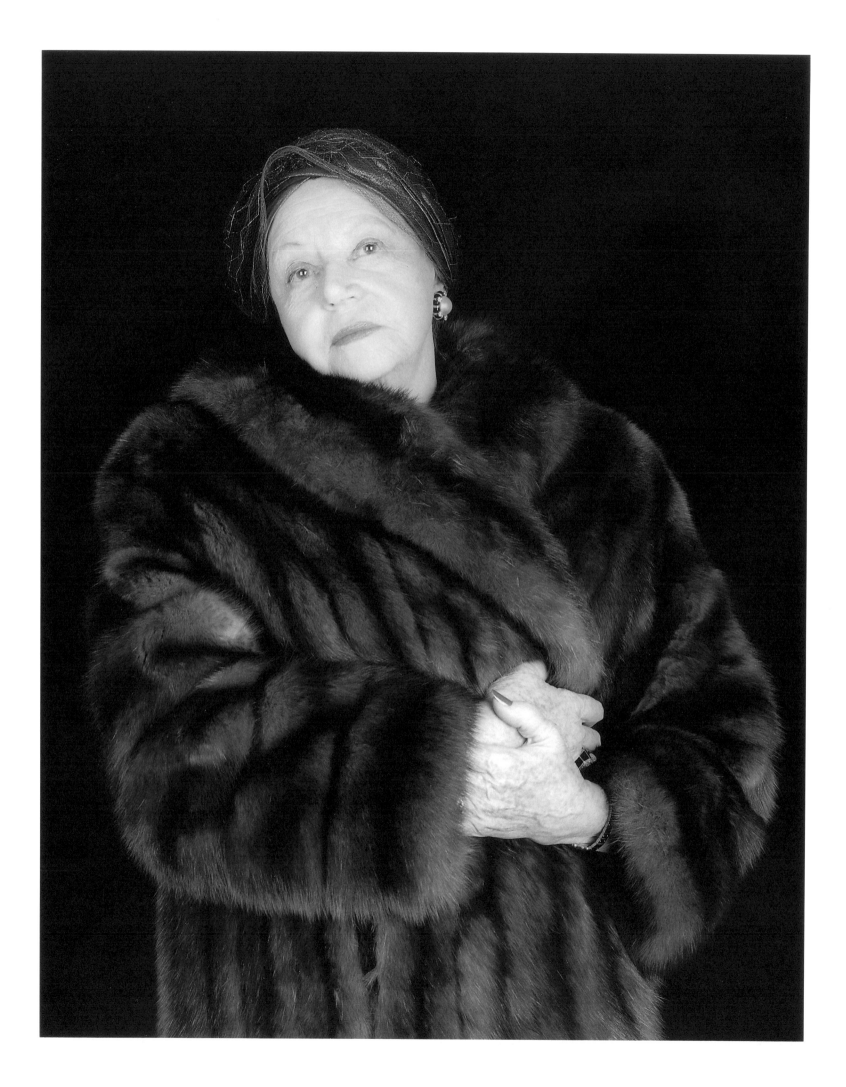

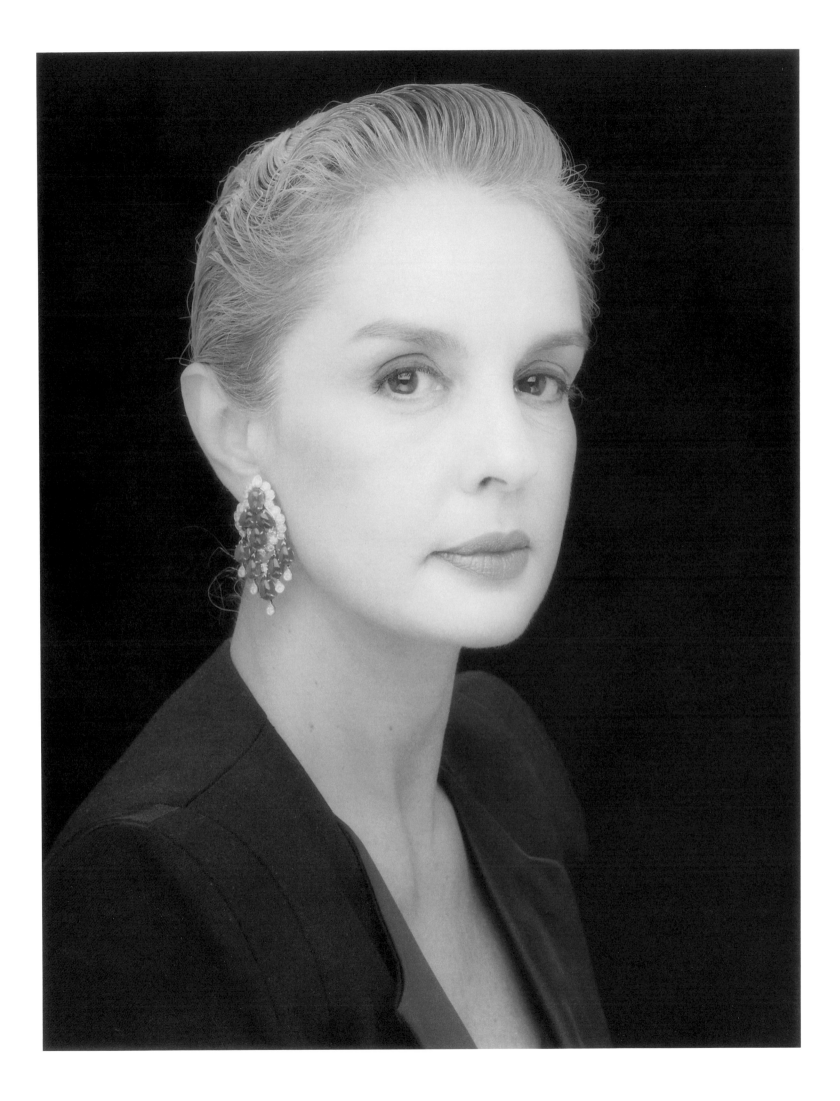

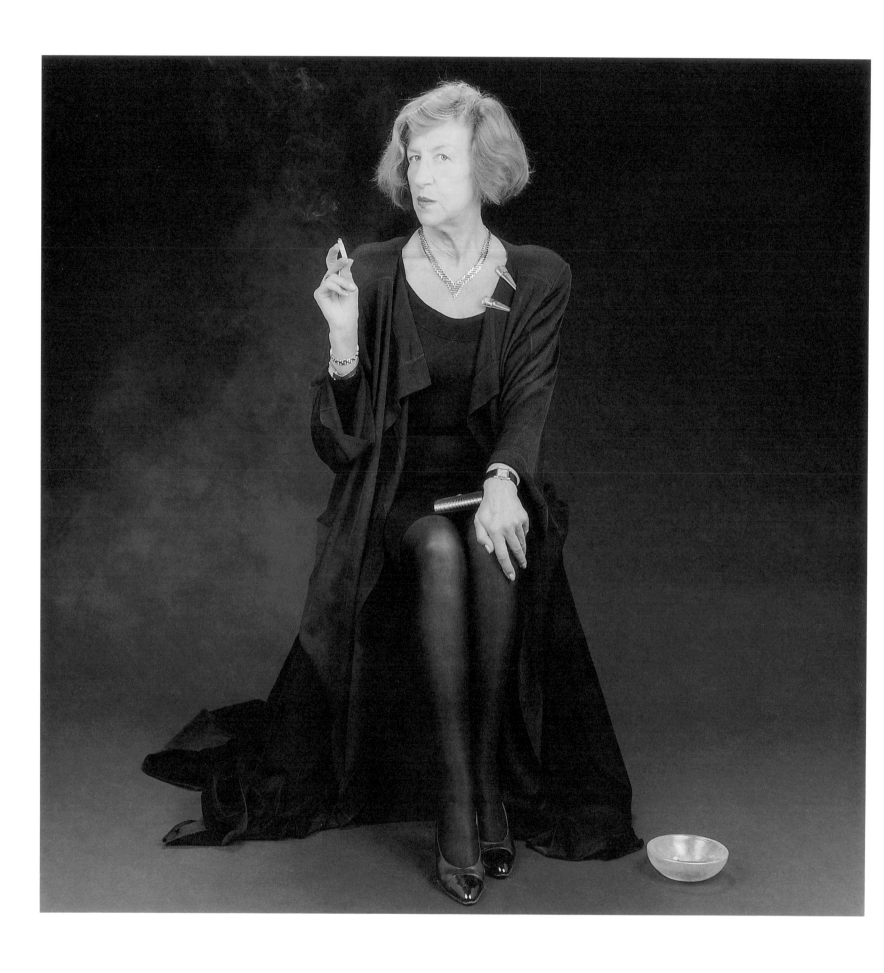

46

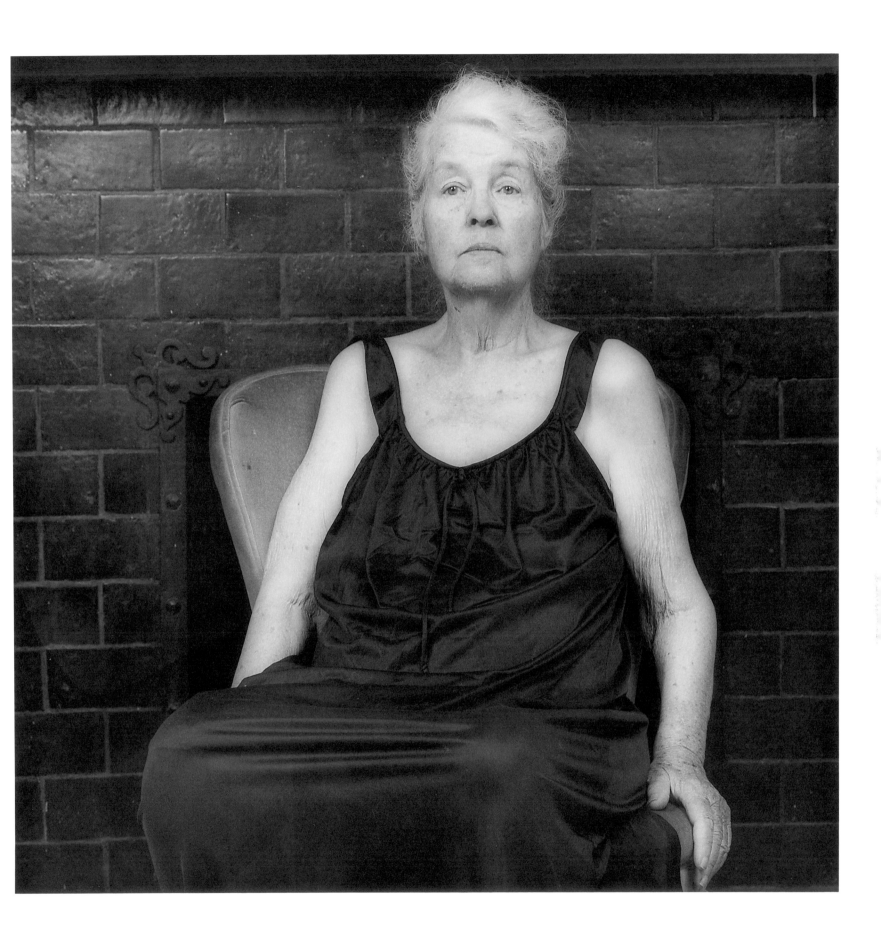

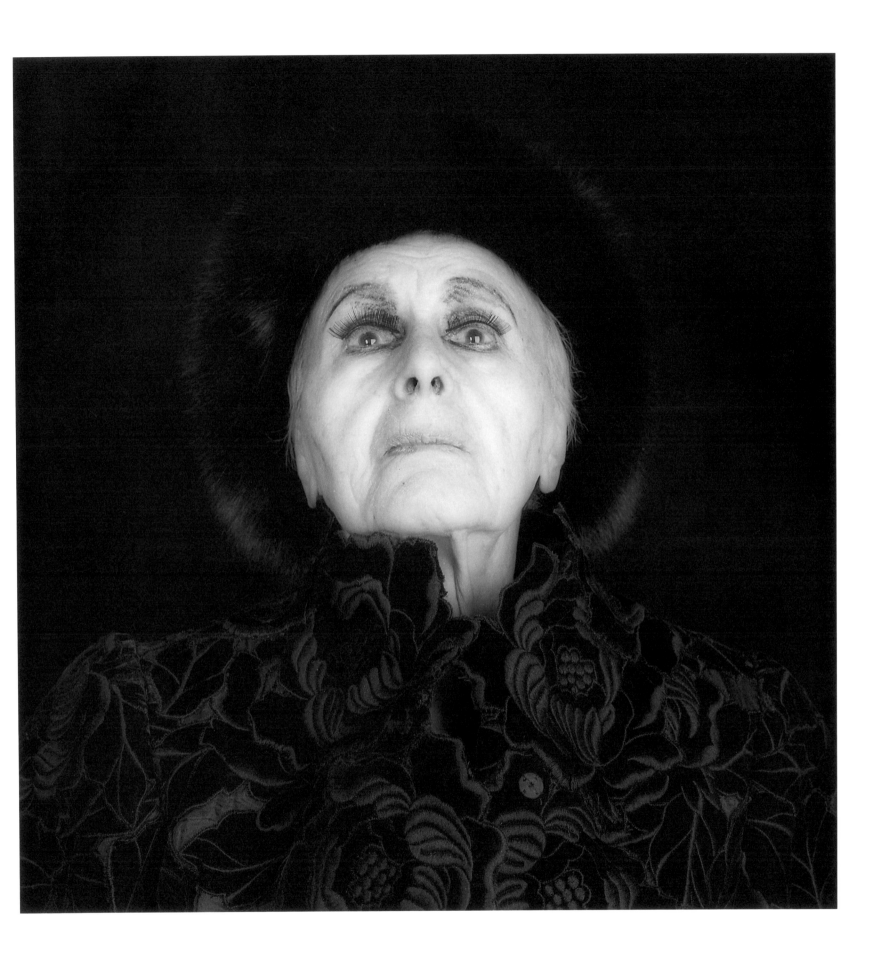

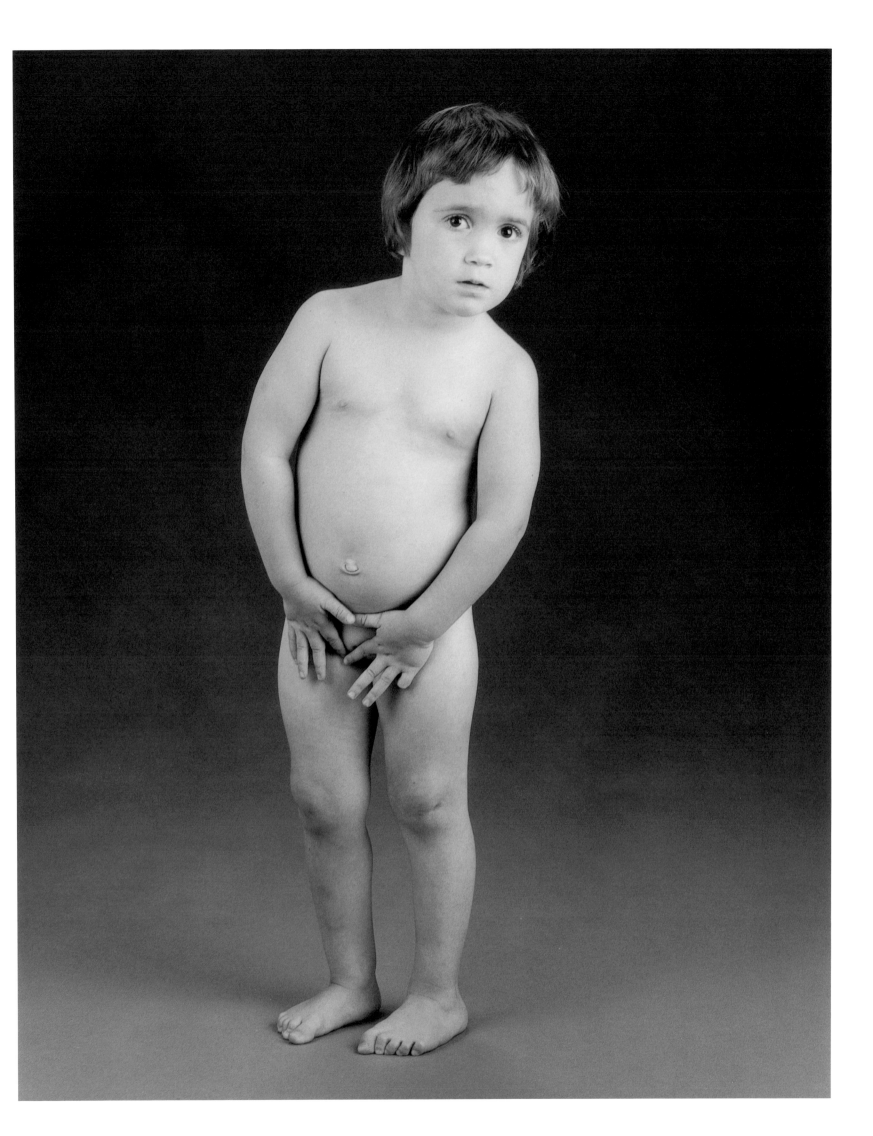

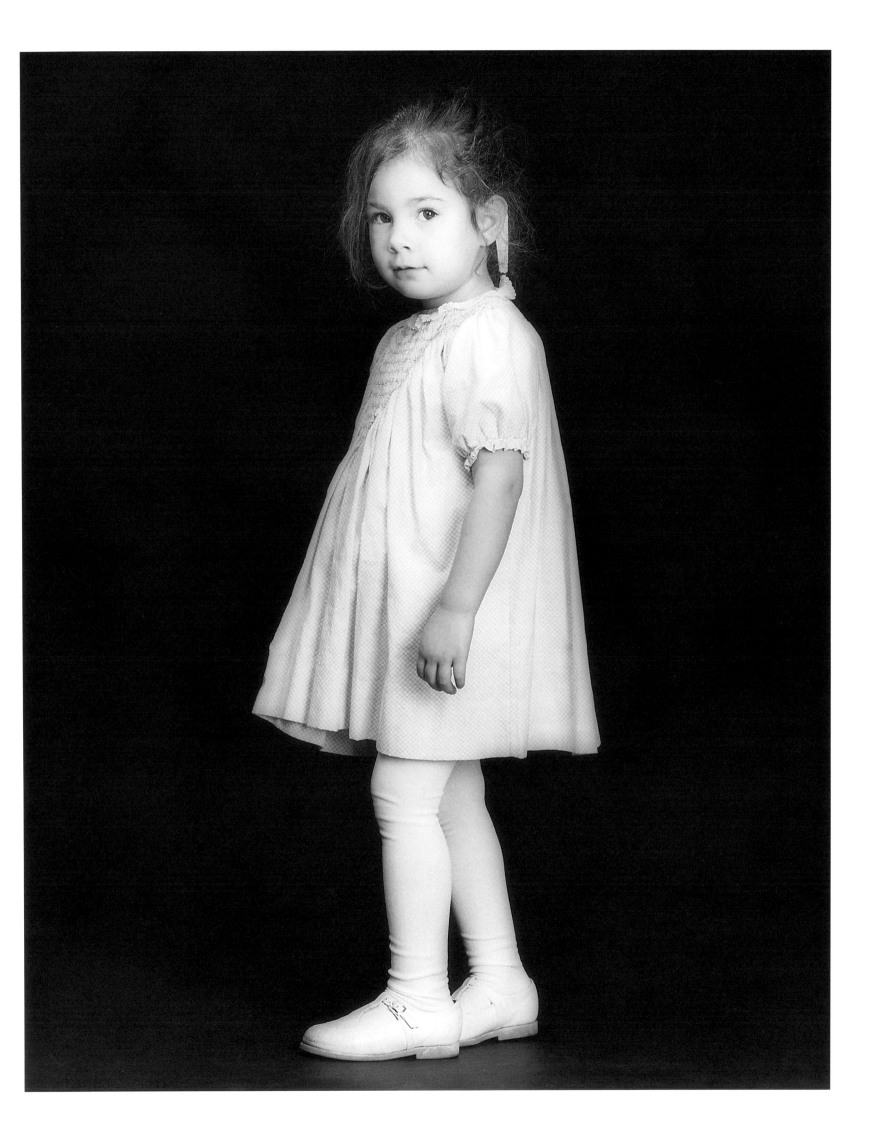

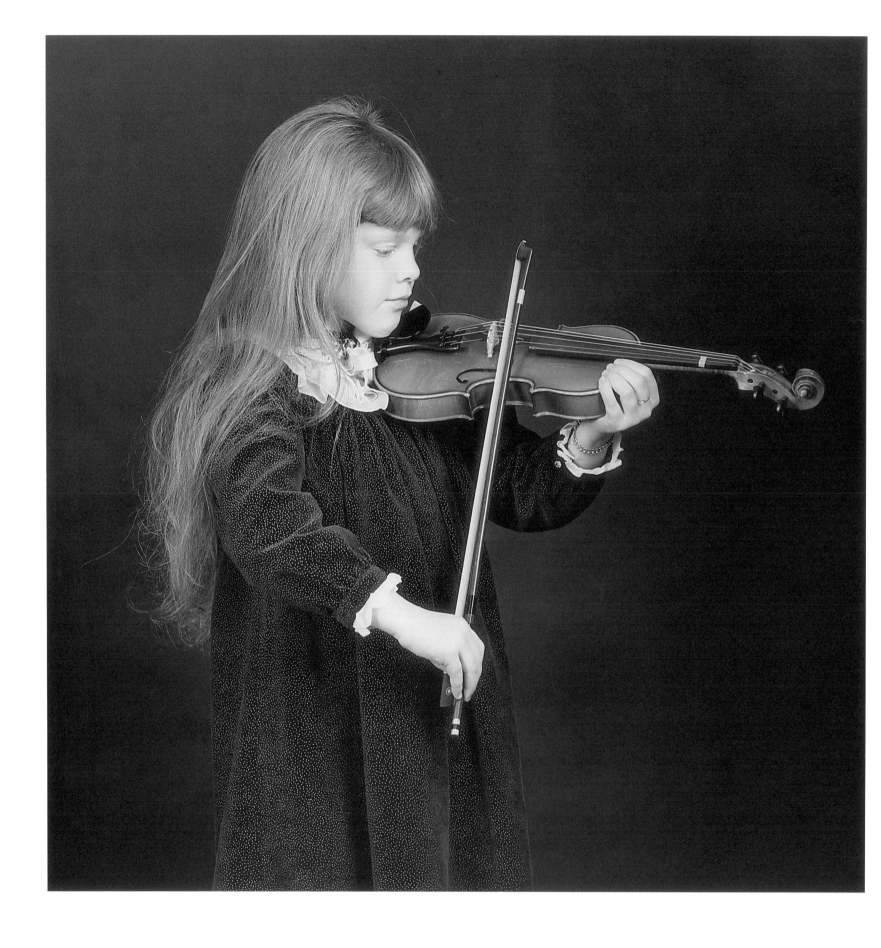

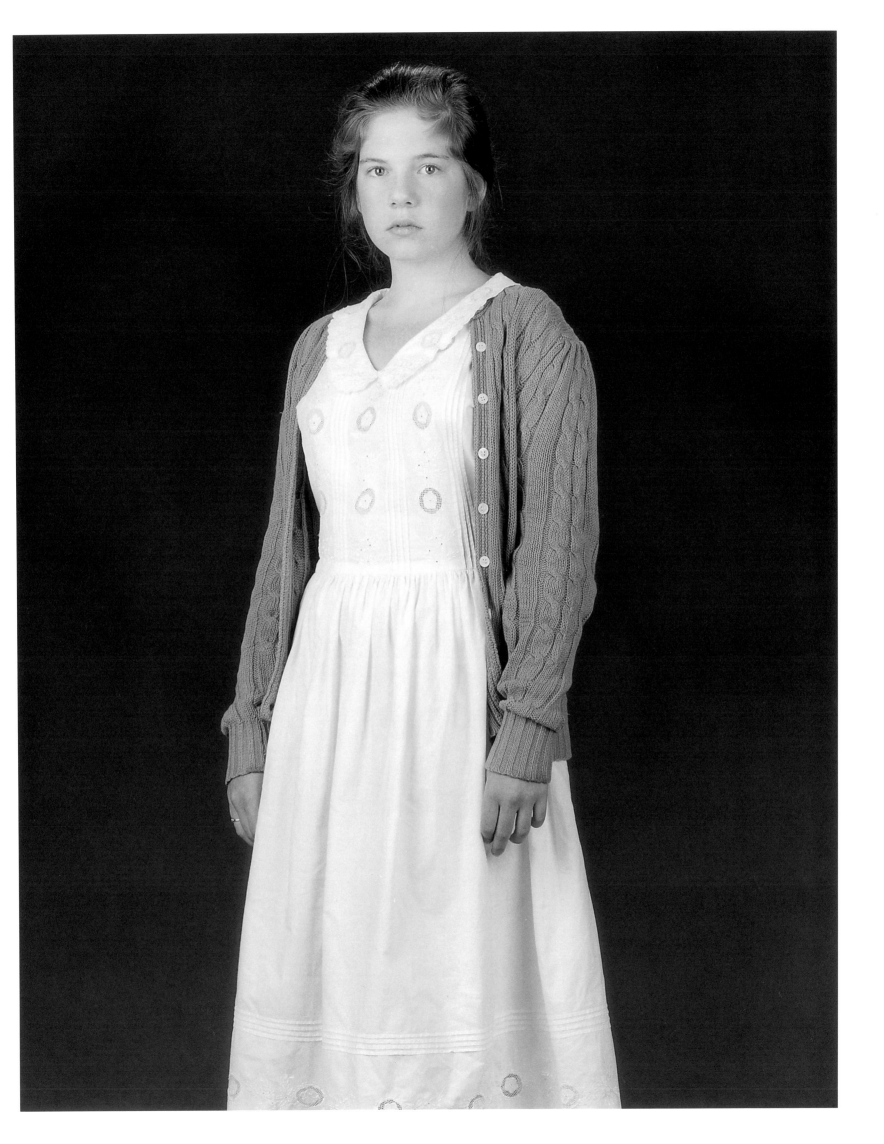

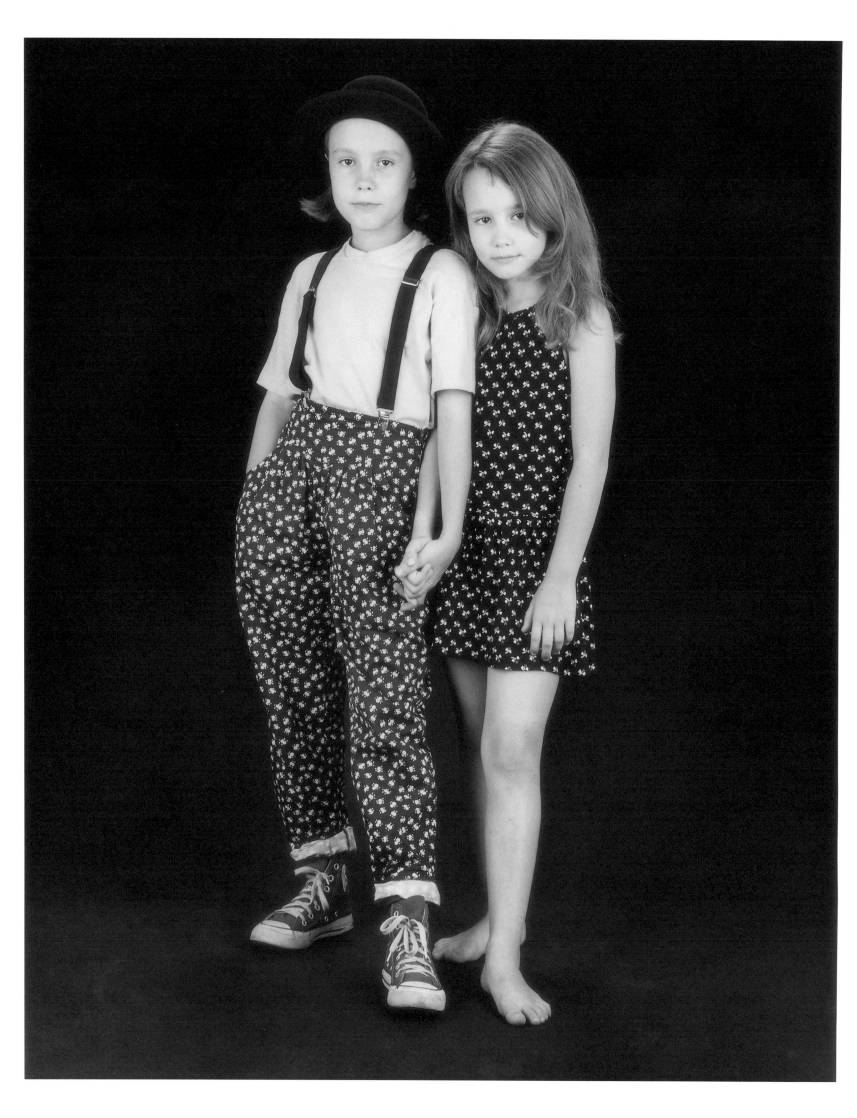

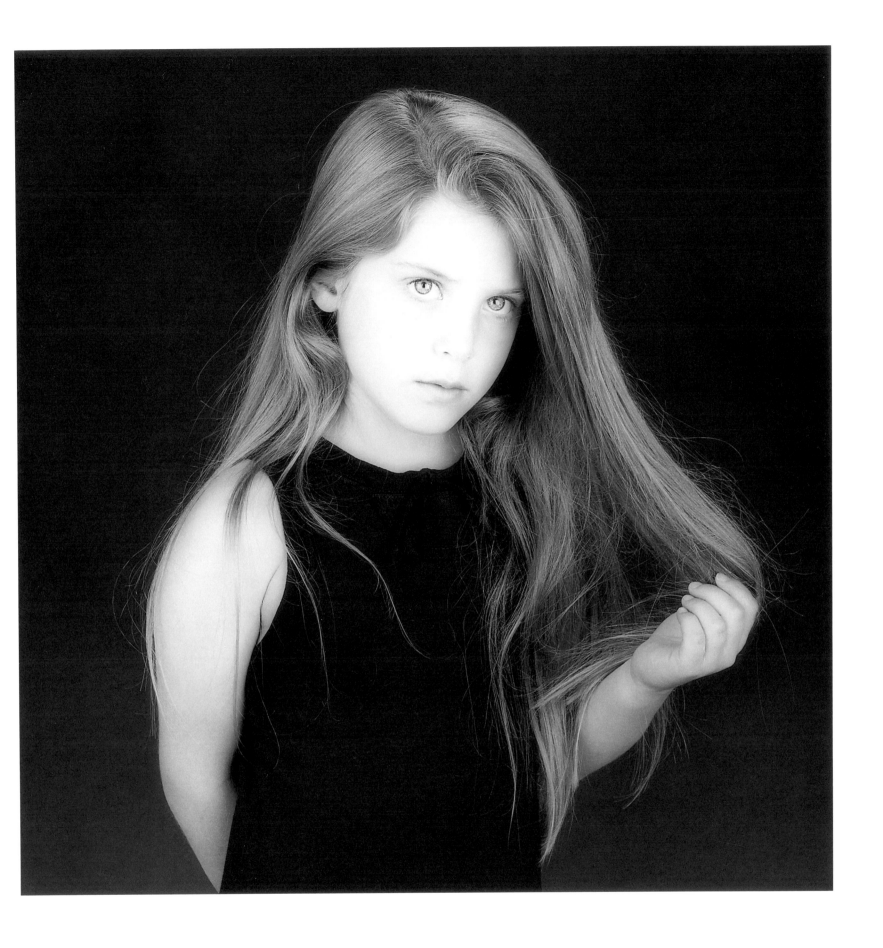

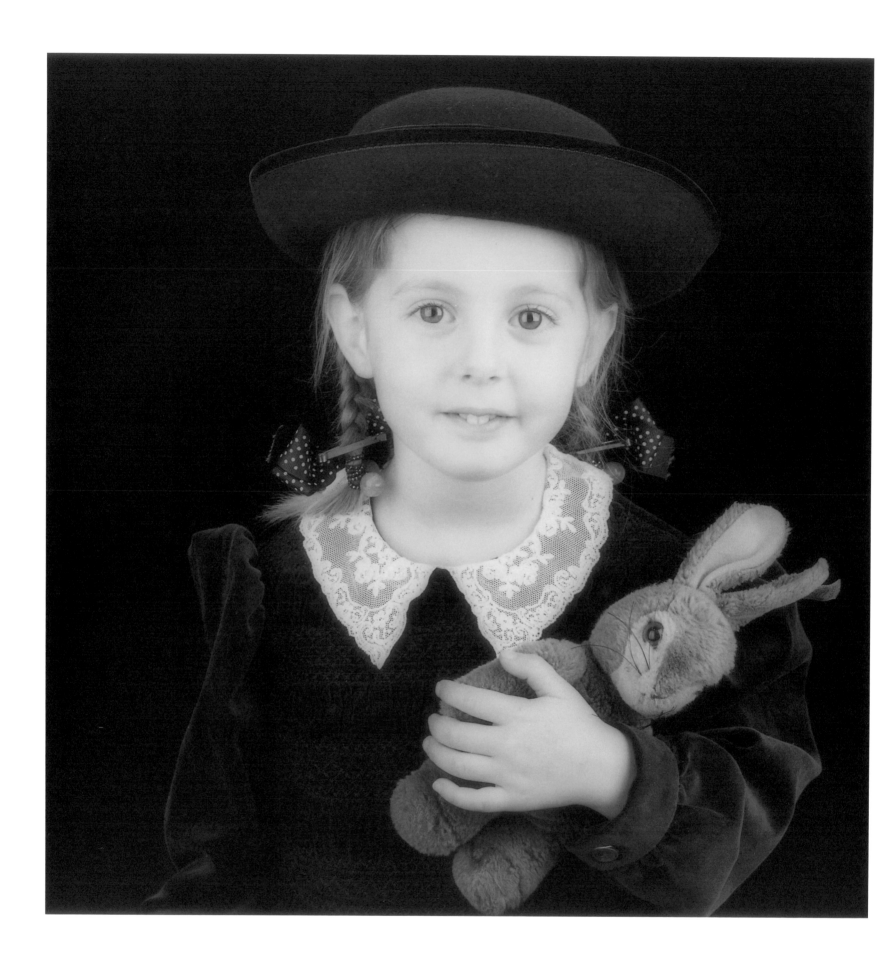

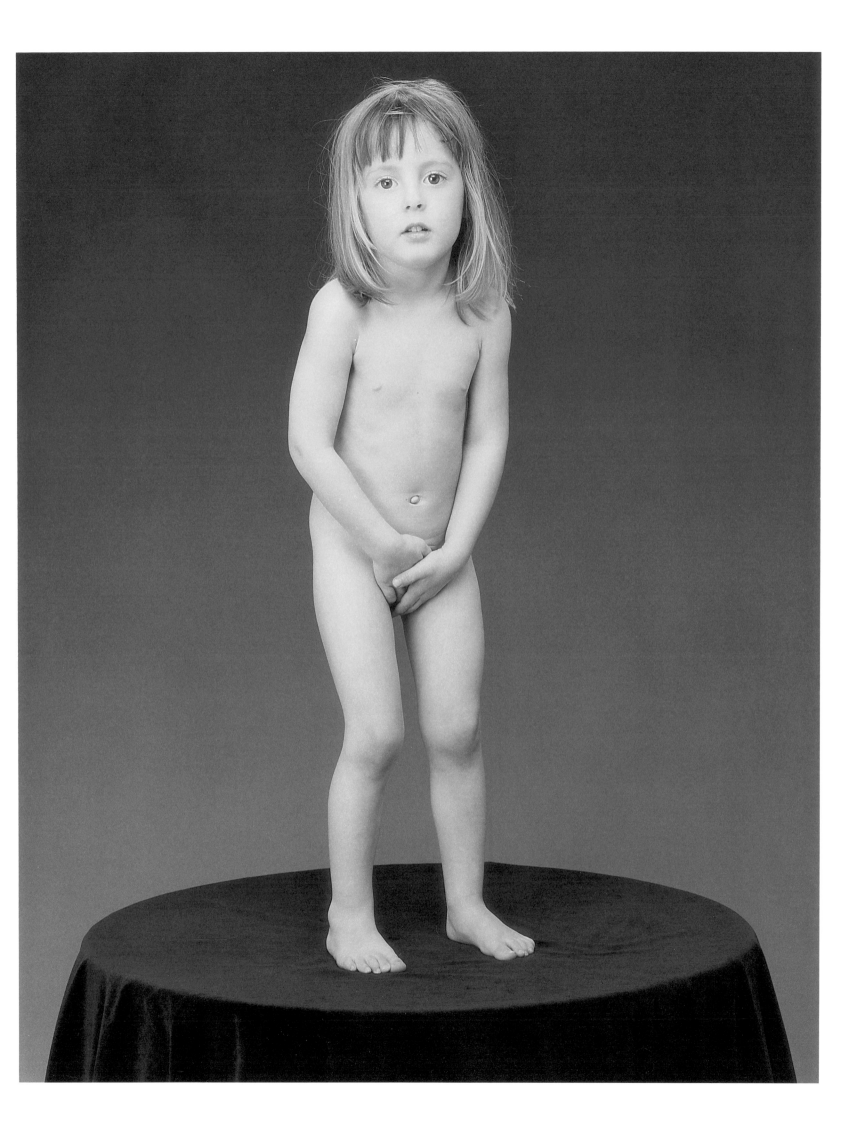

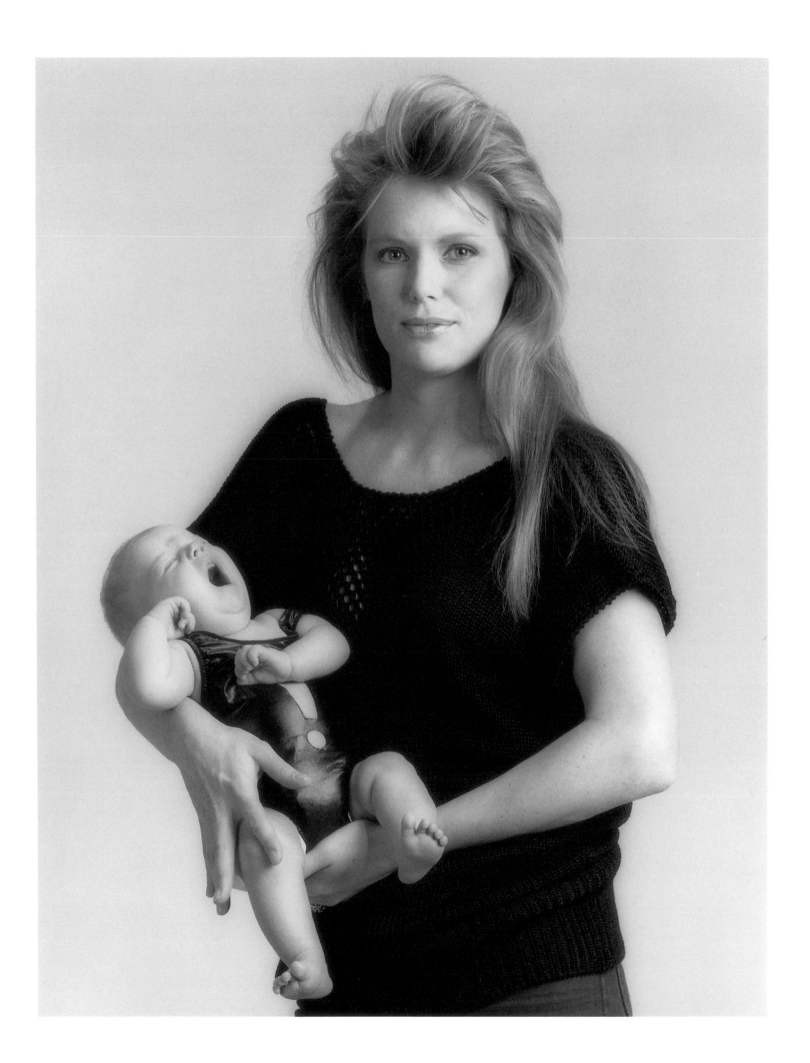

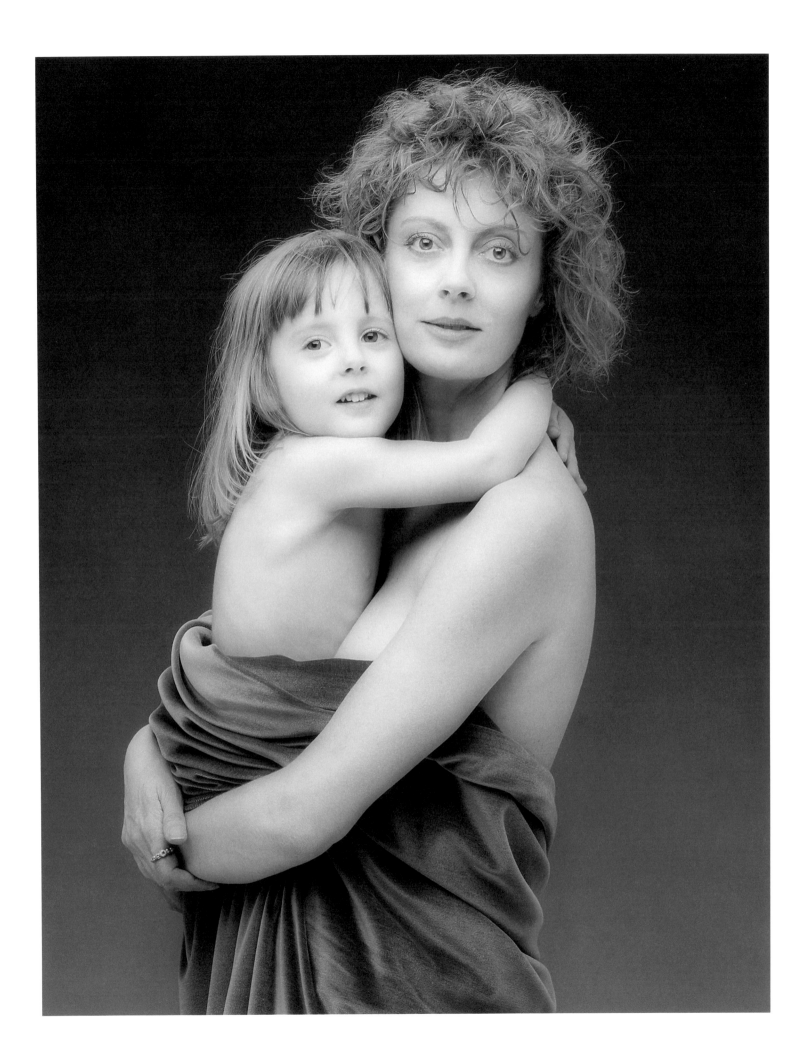

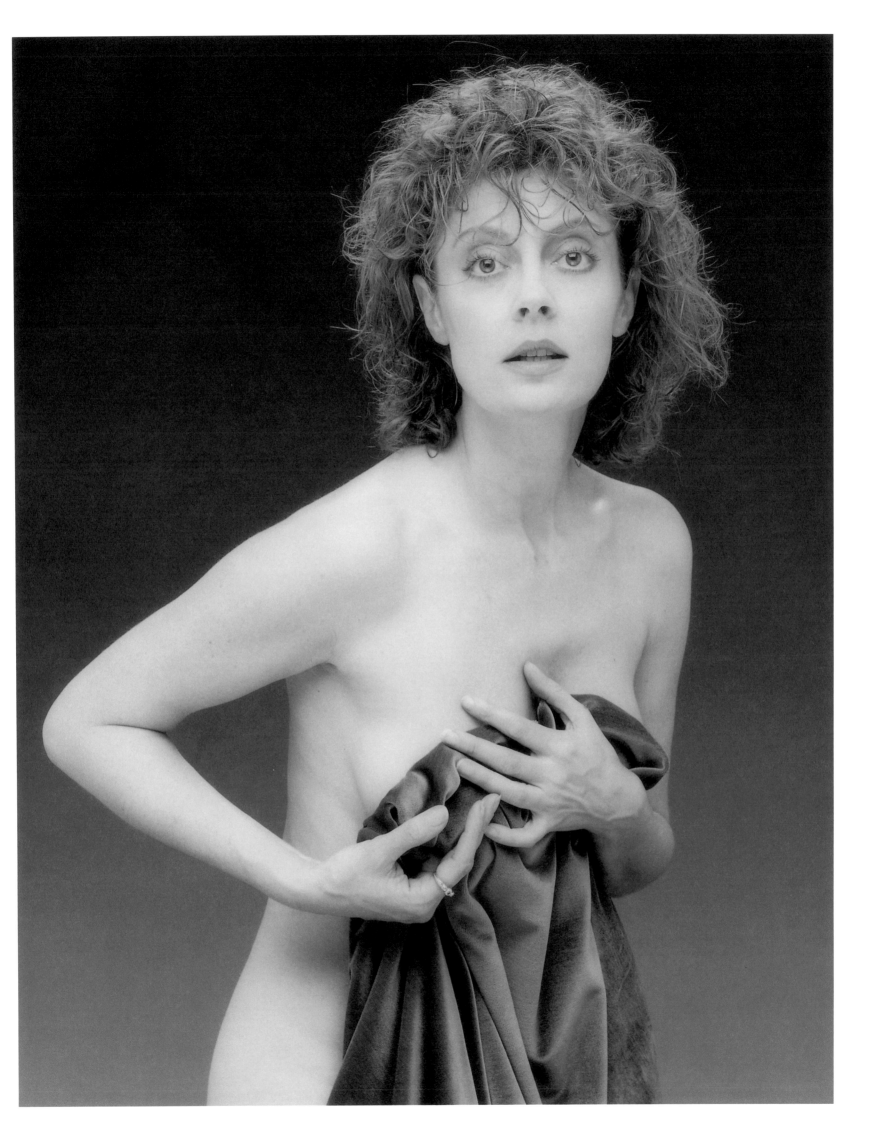

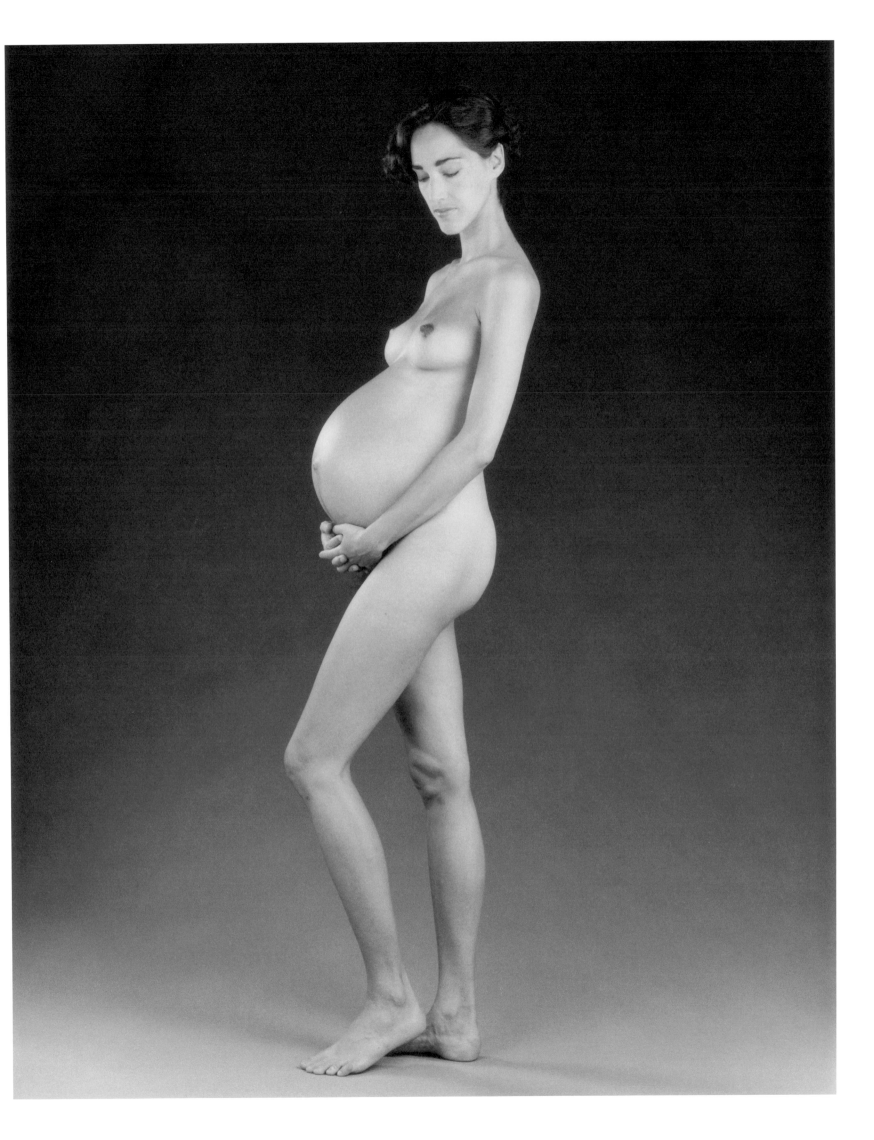

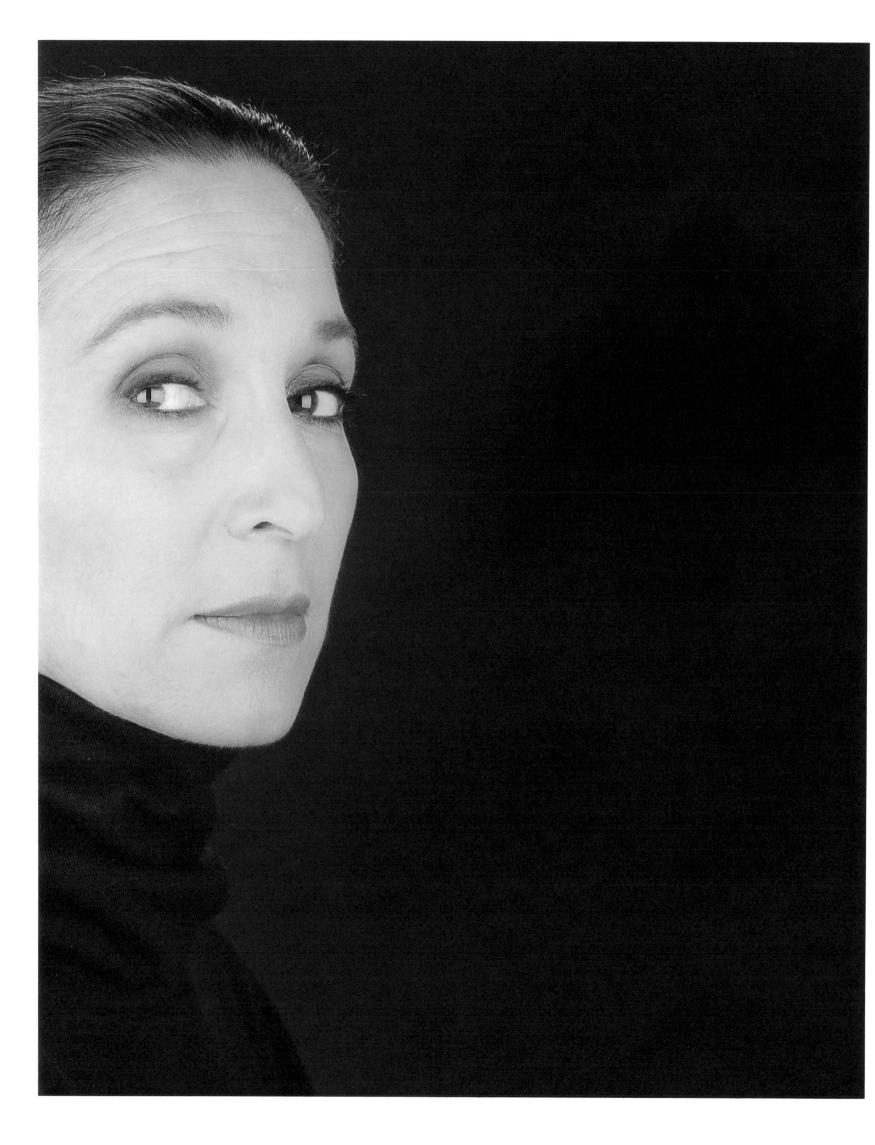

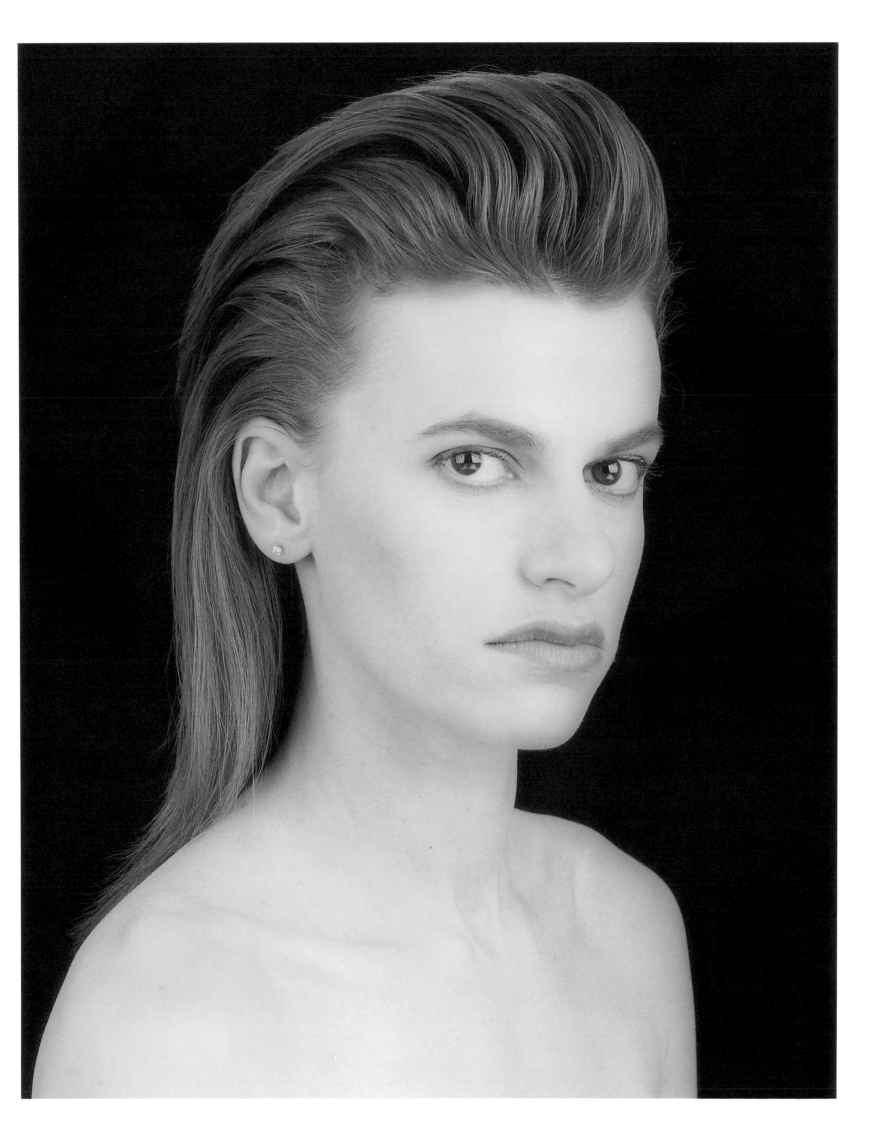

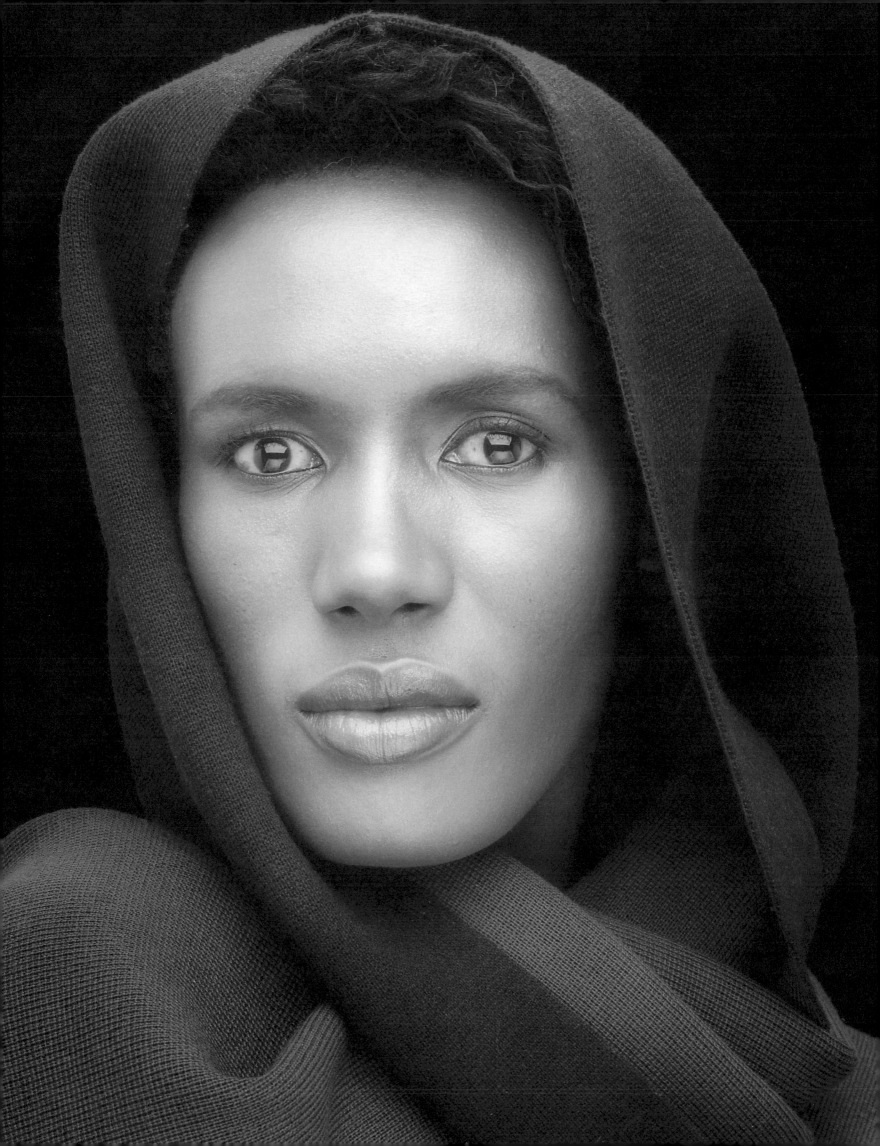

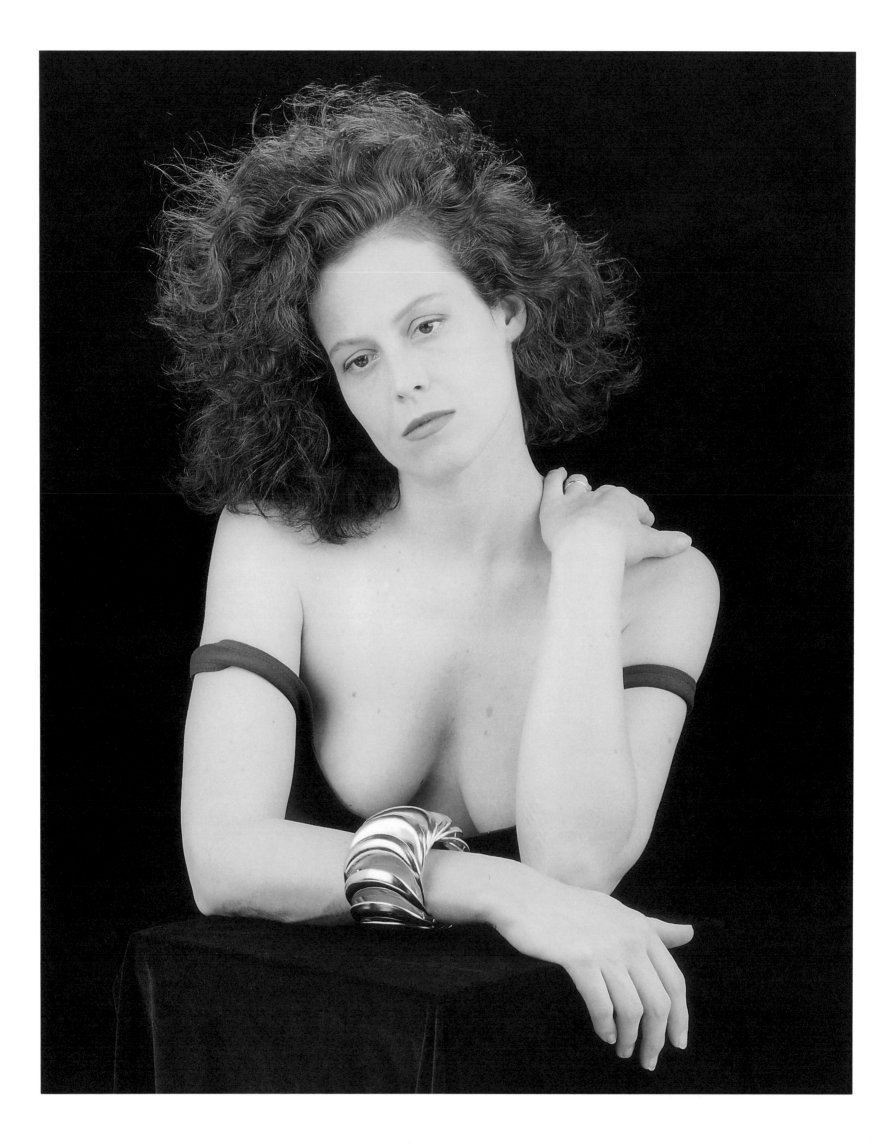

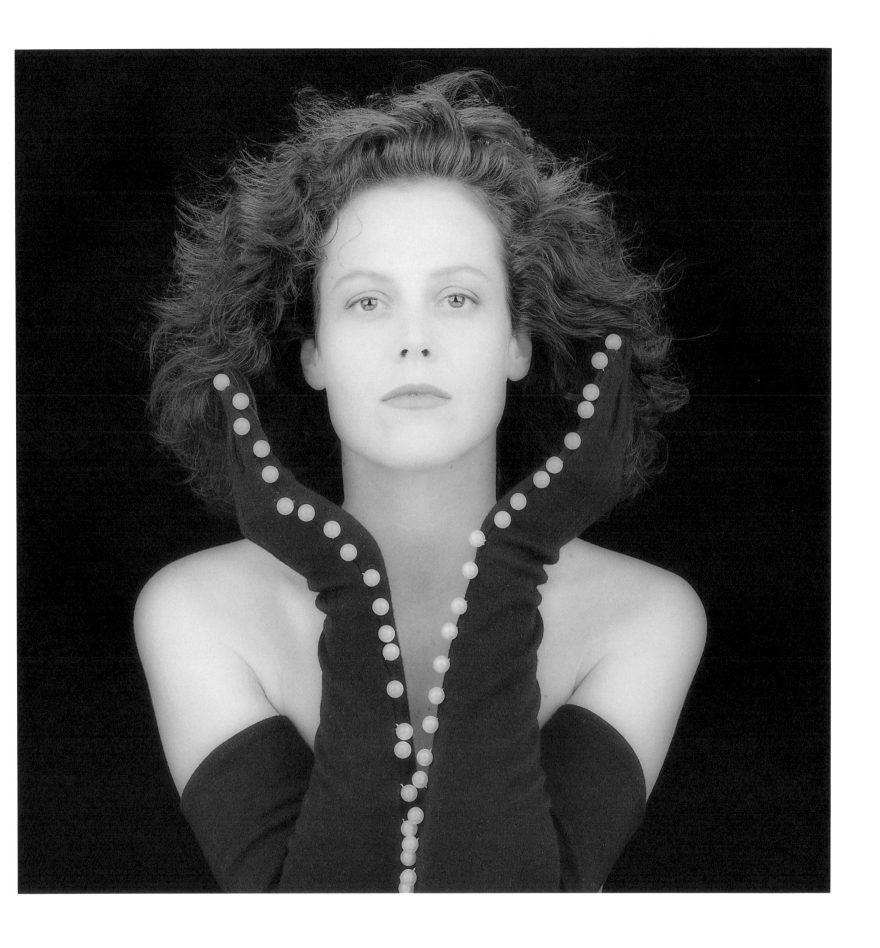

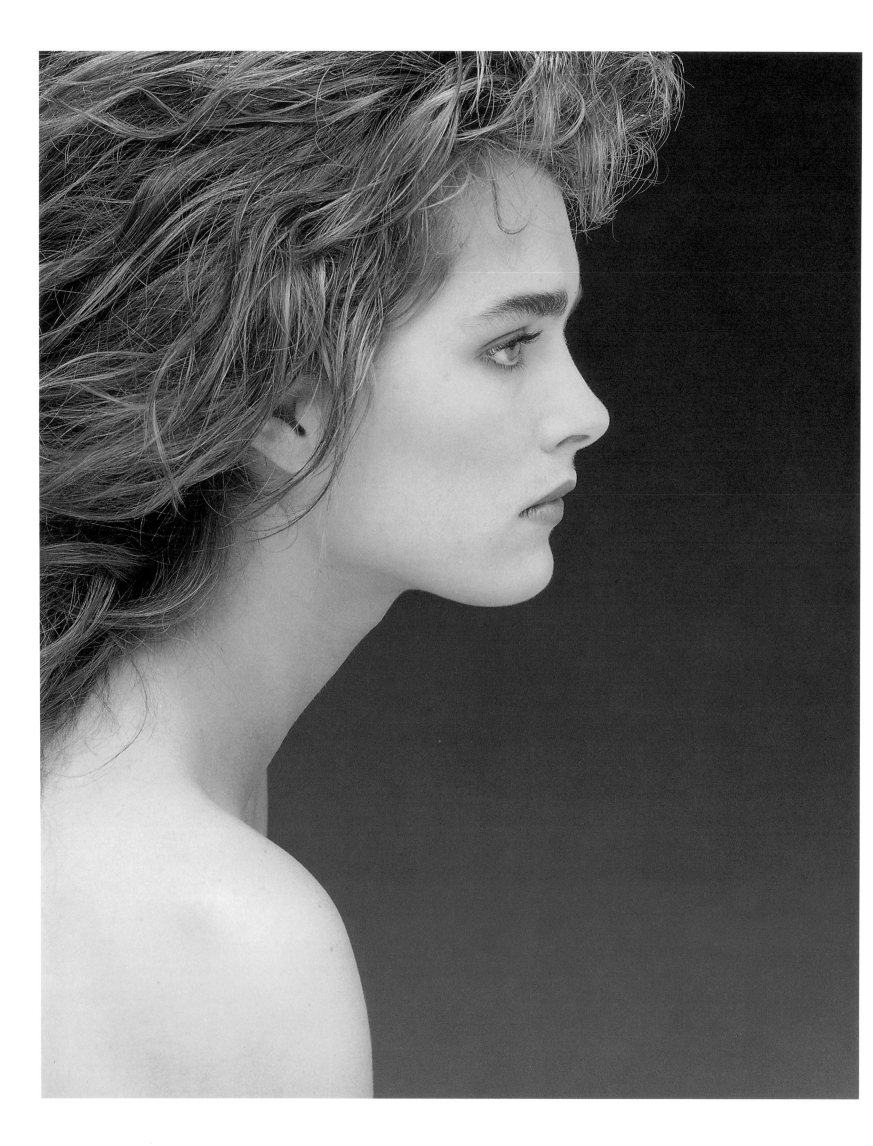

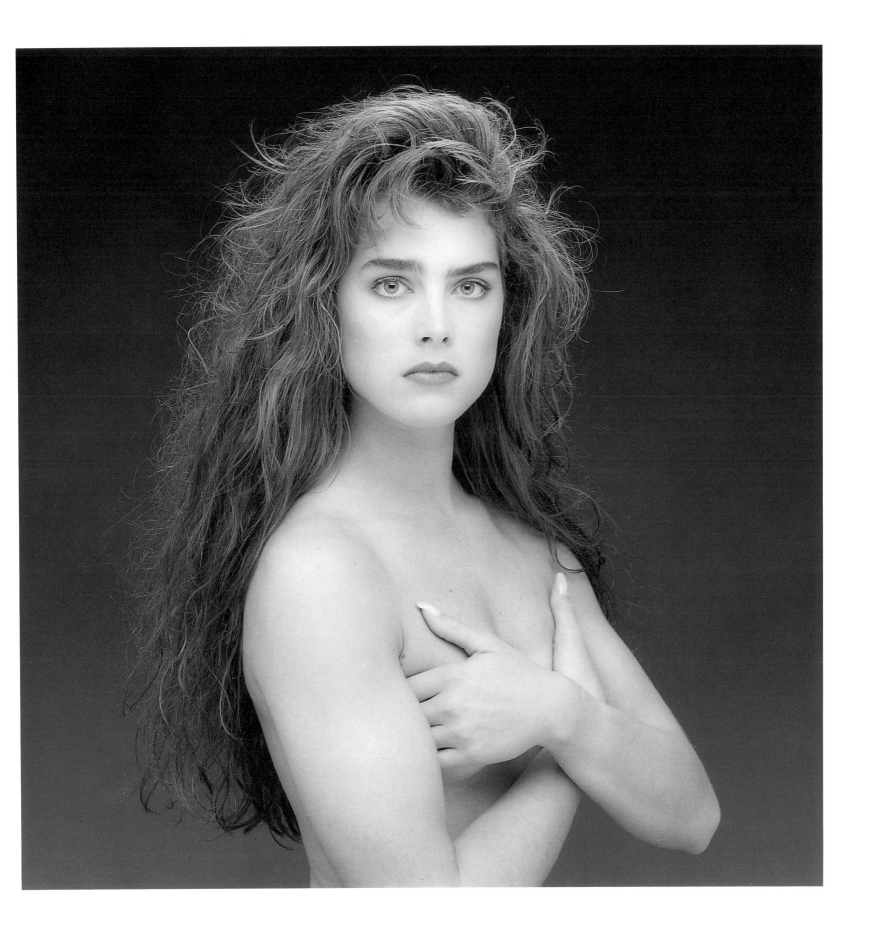

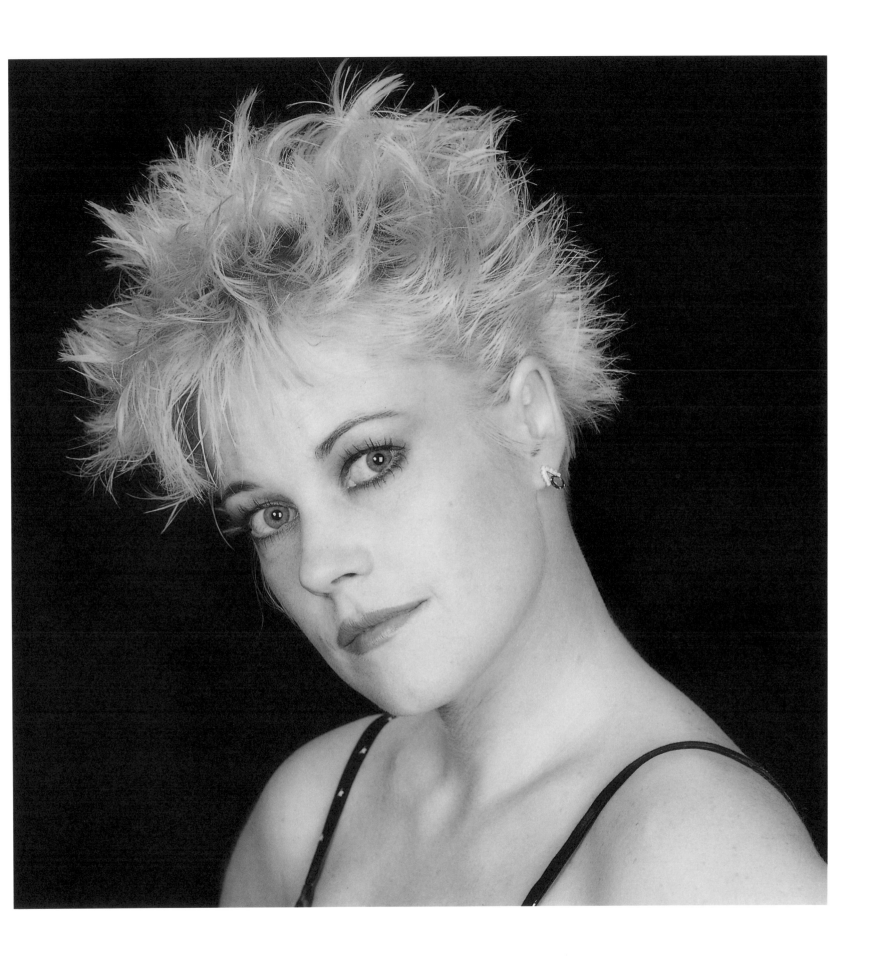

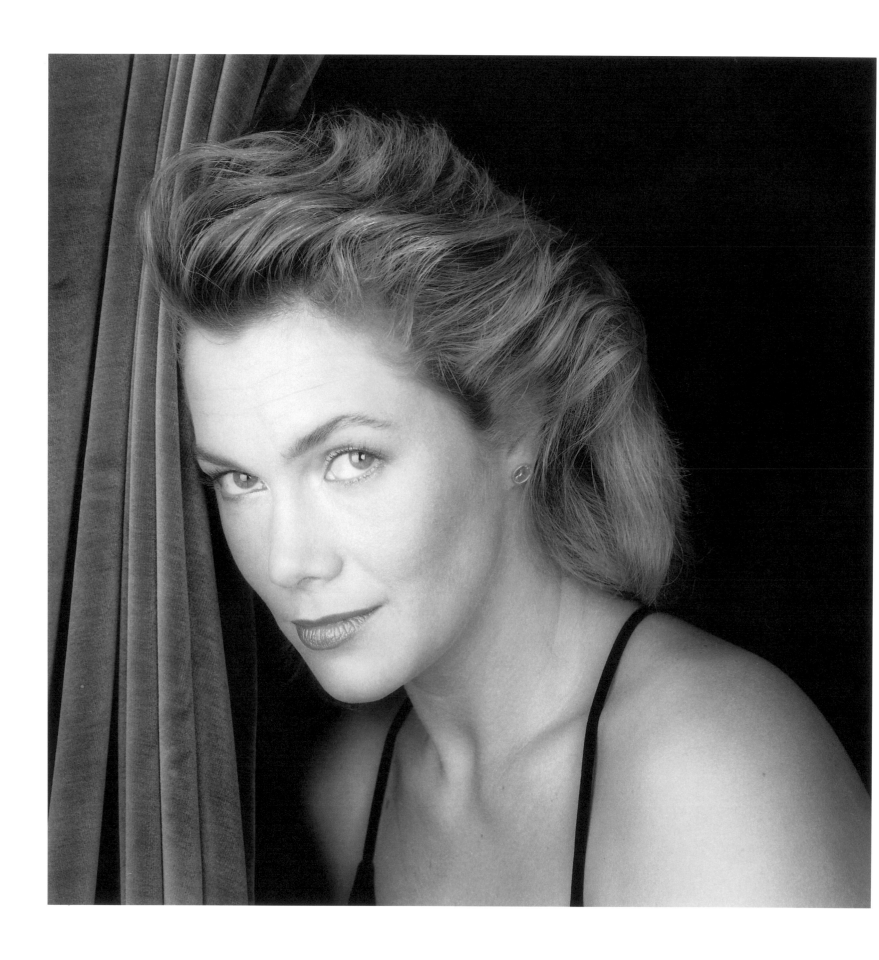

76

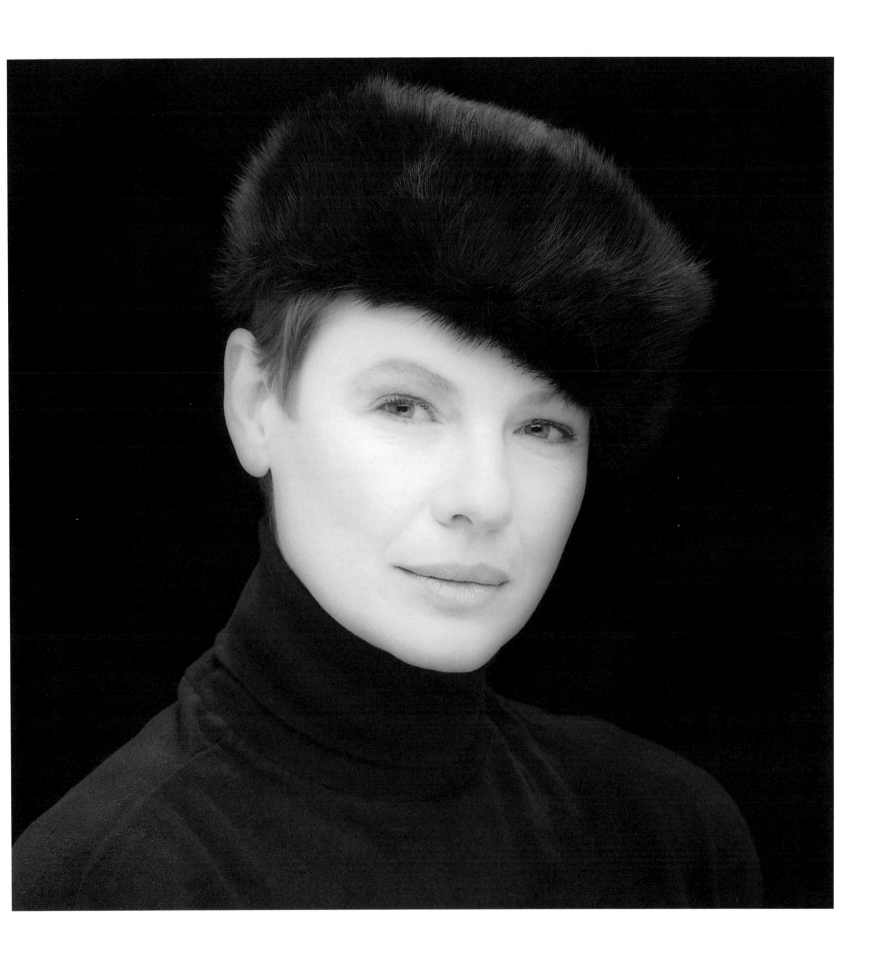

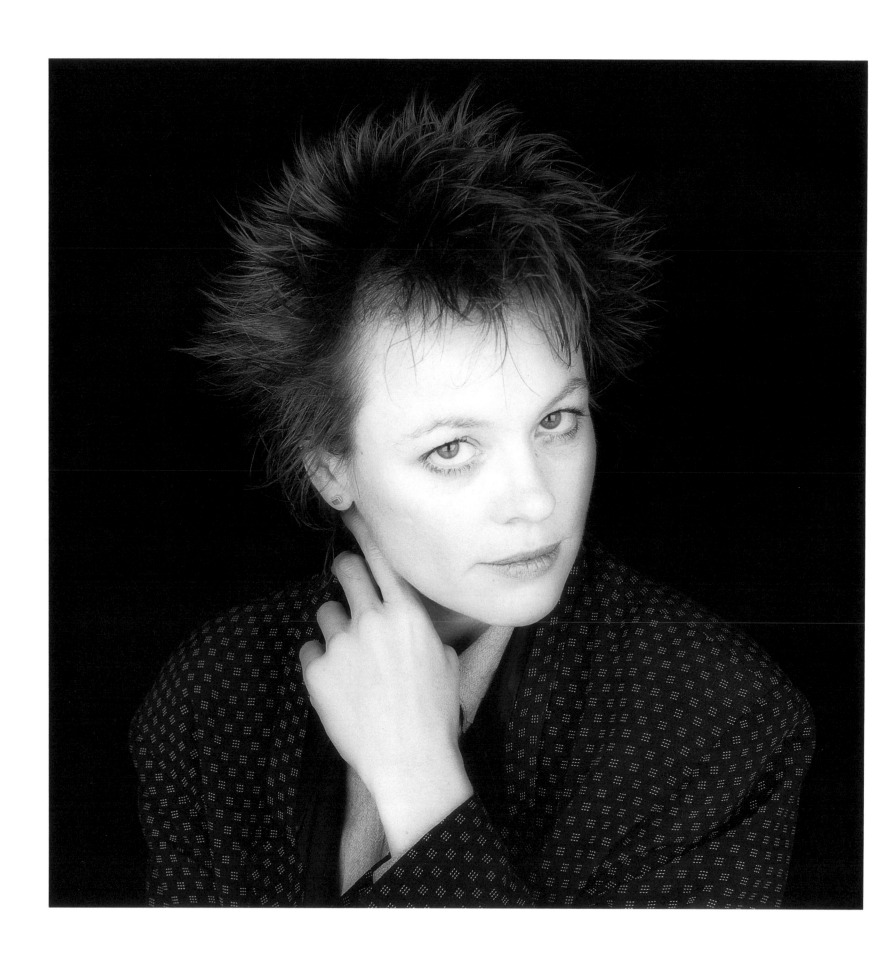

78

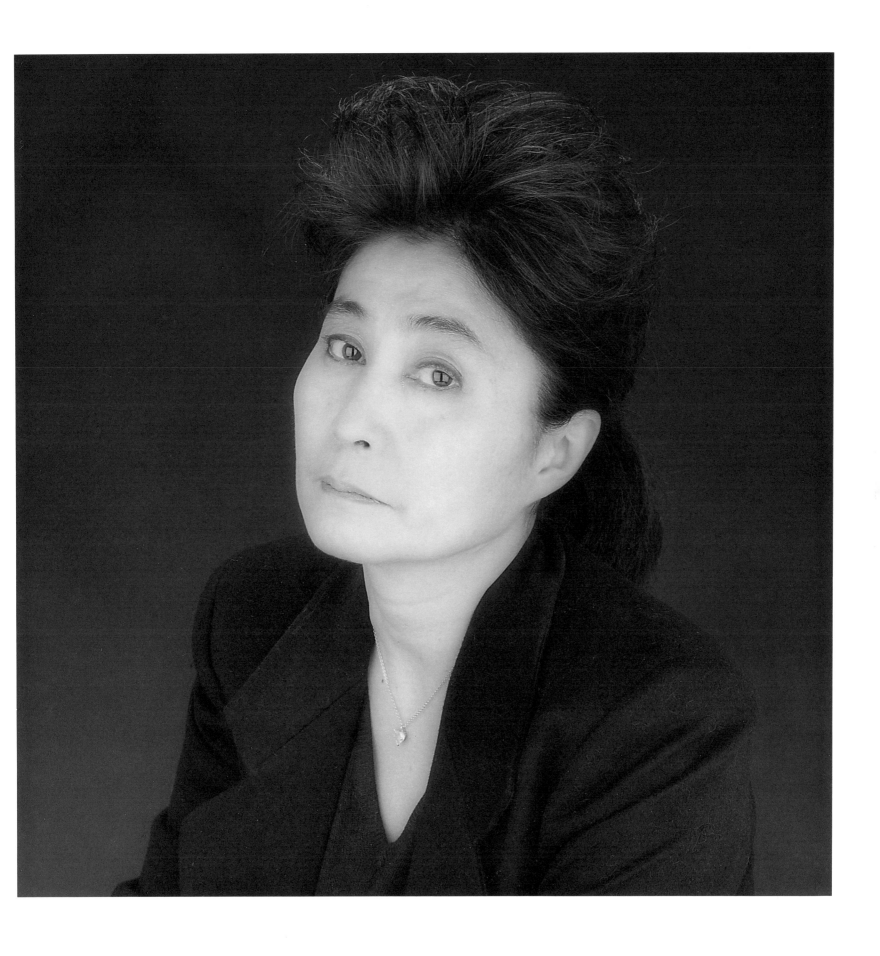

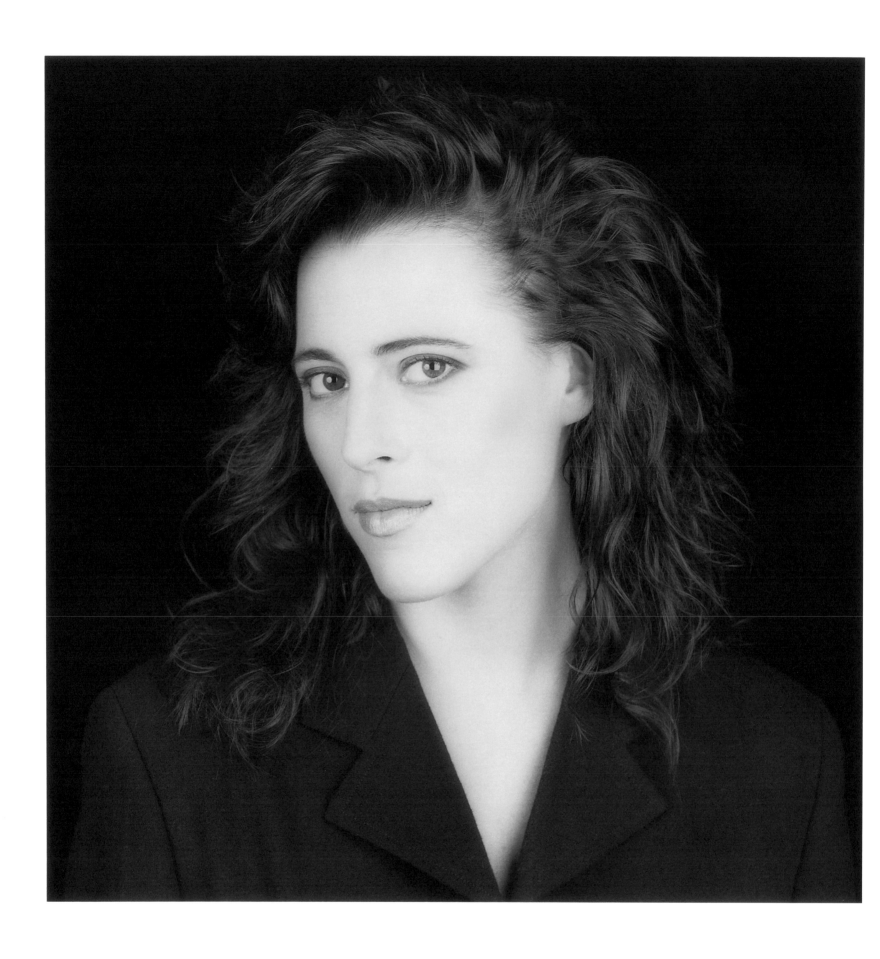

80

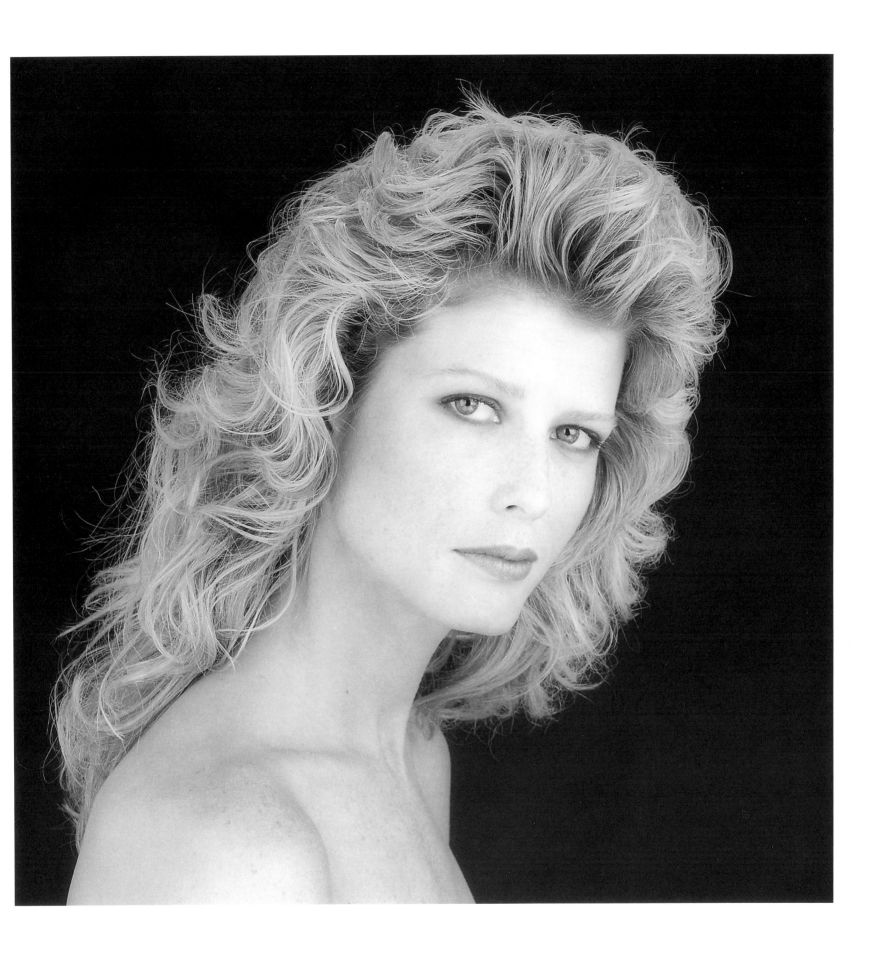

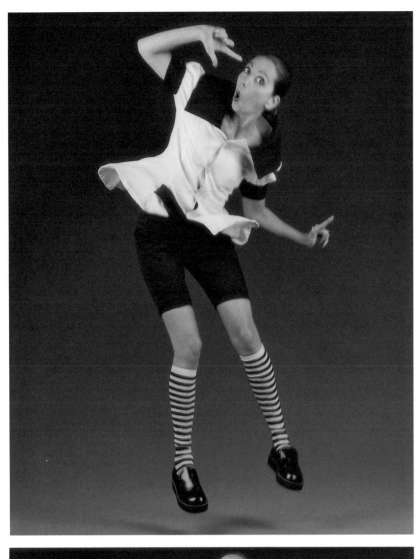
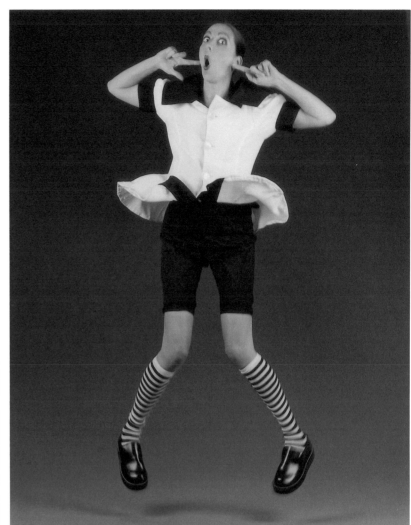
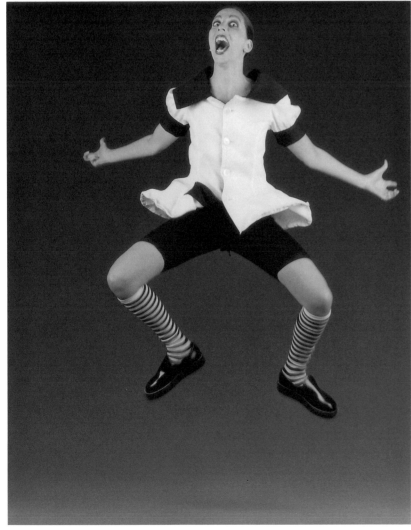
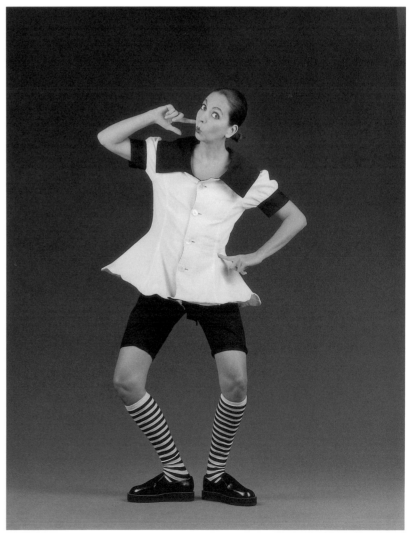

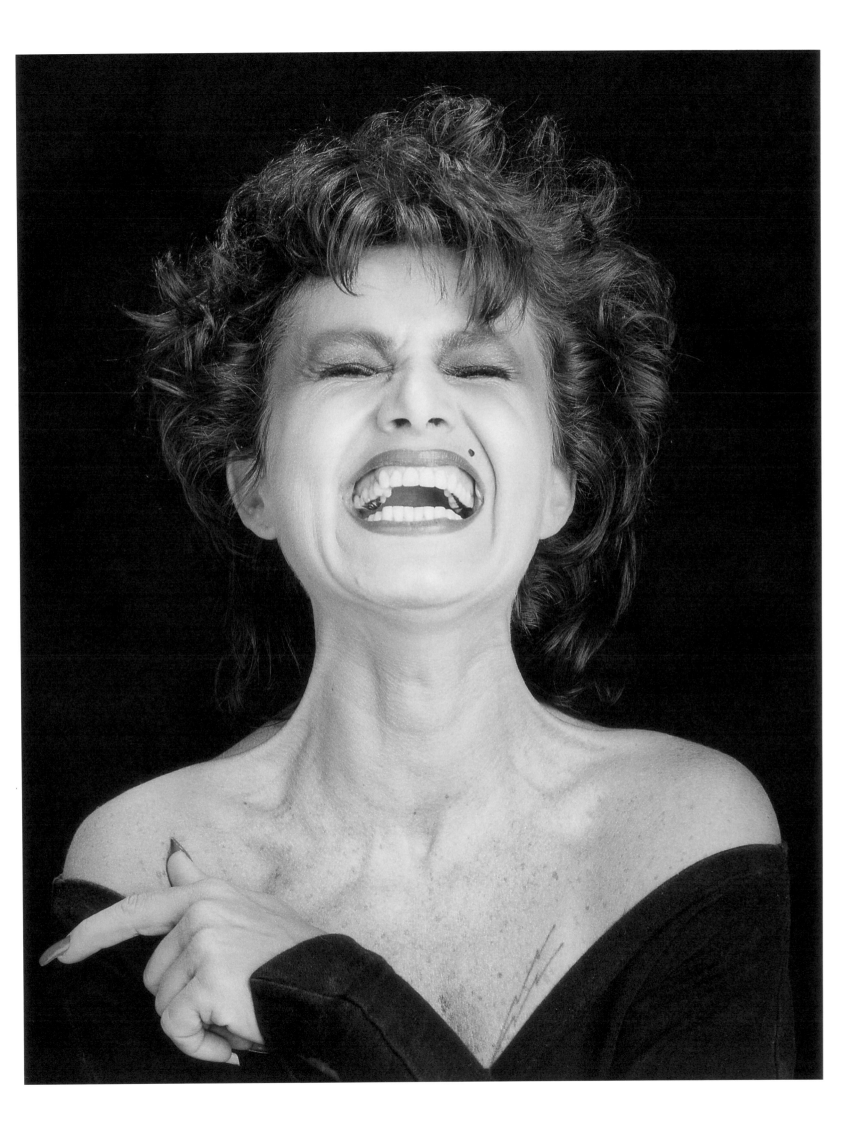

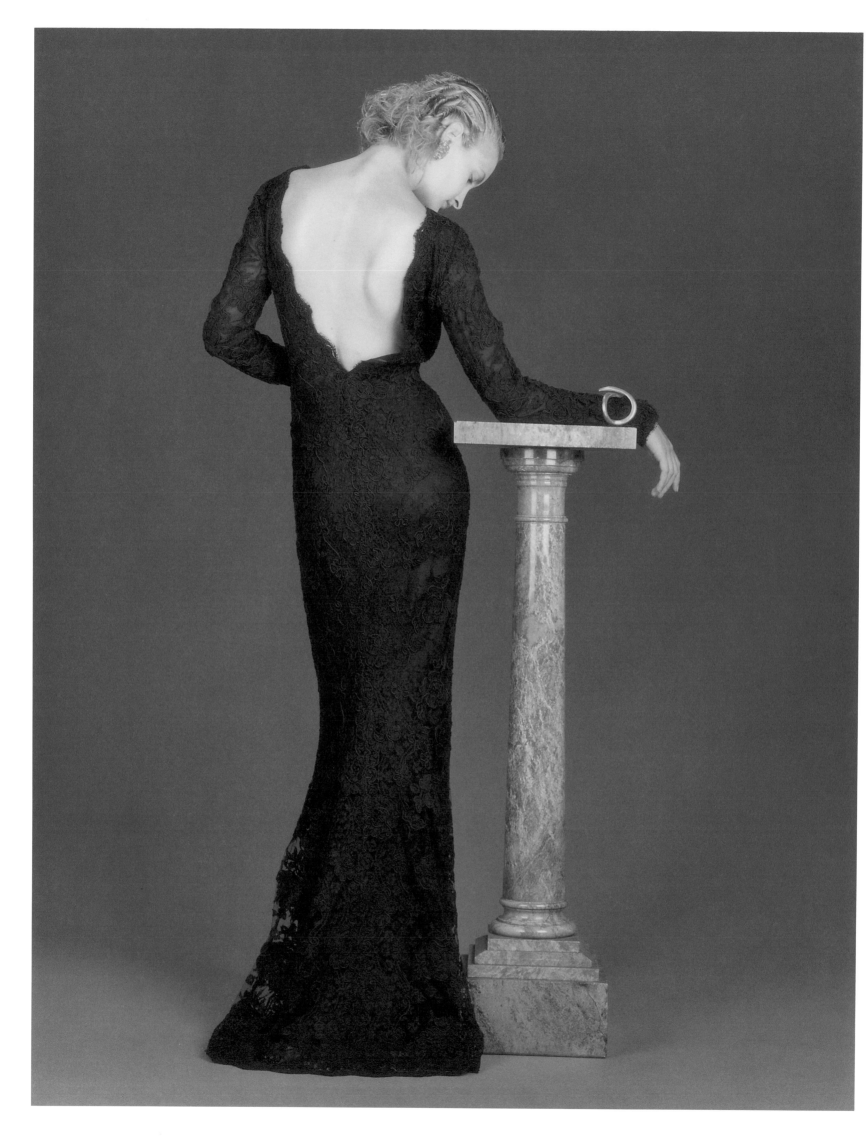

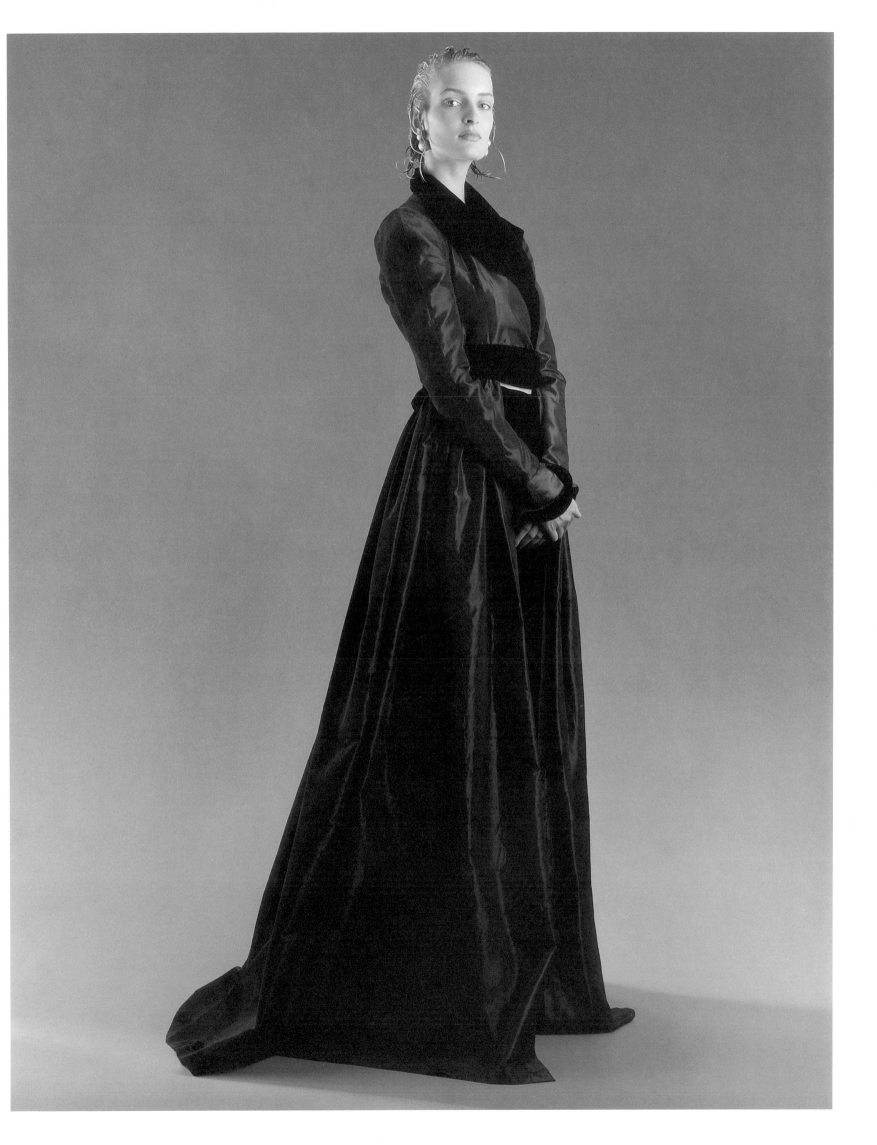

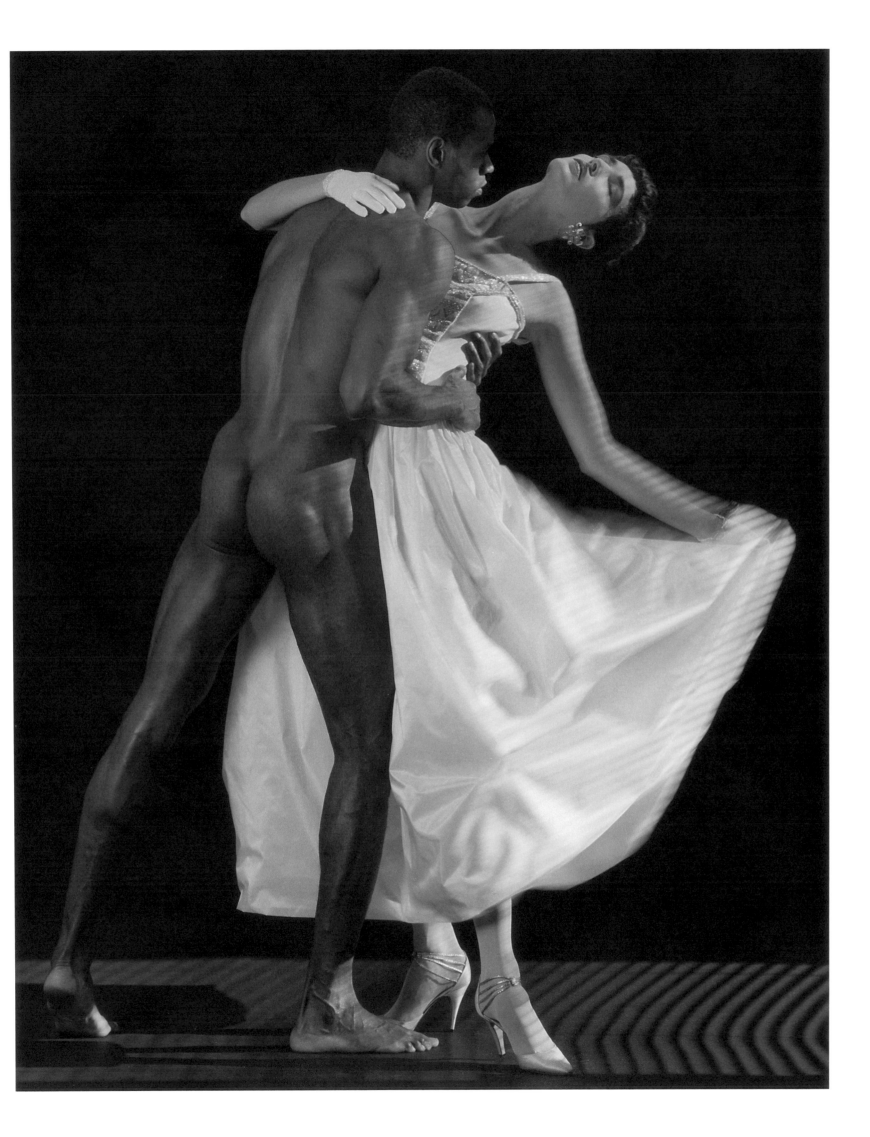

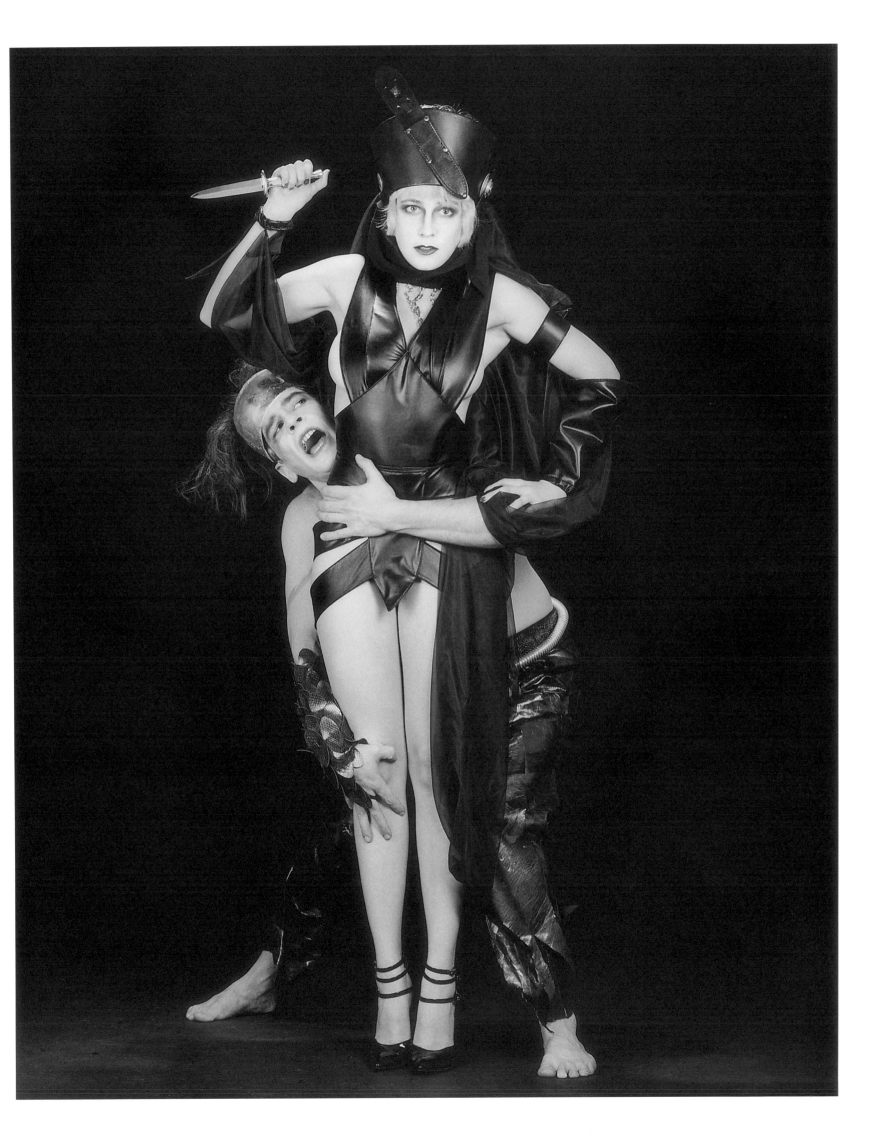

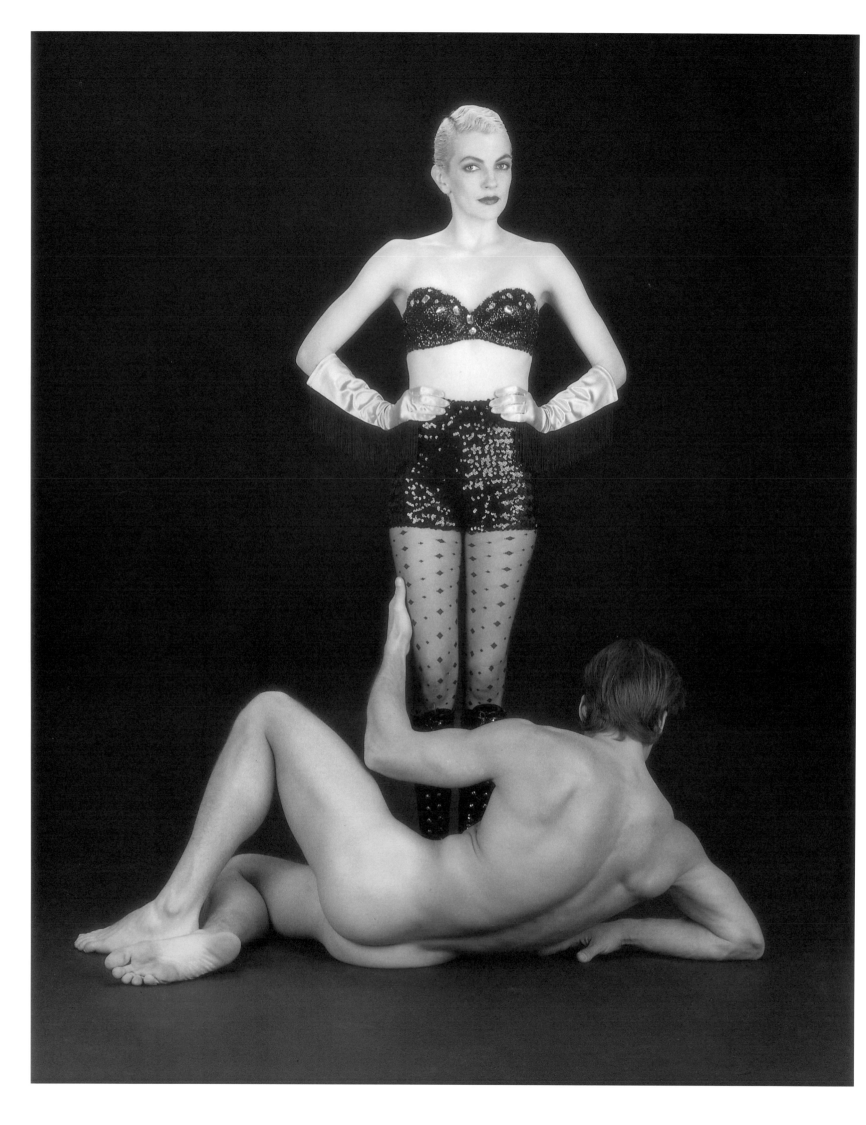

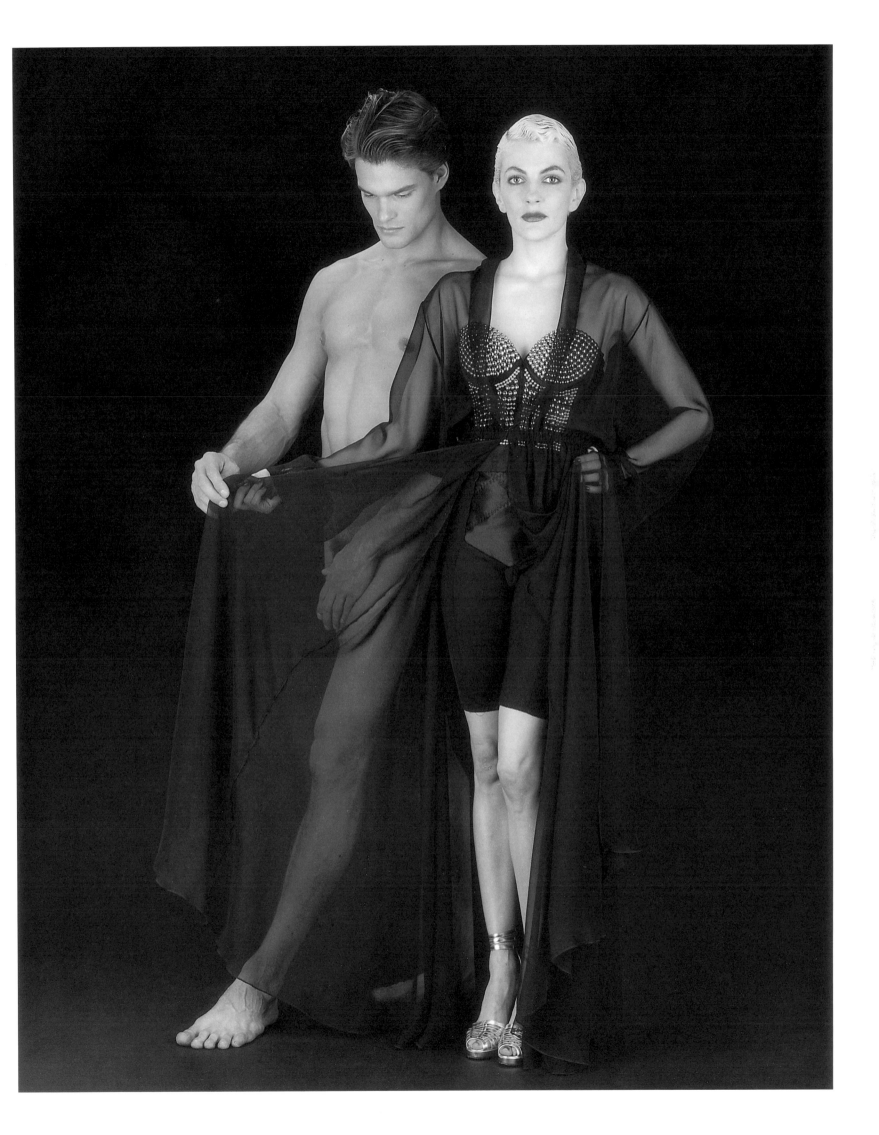

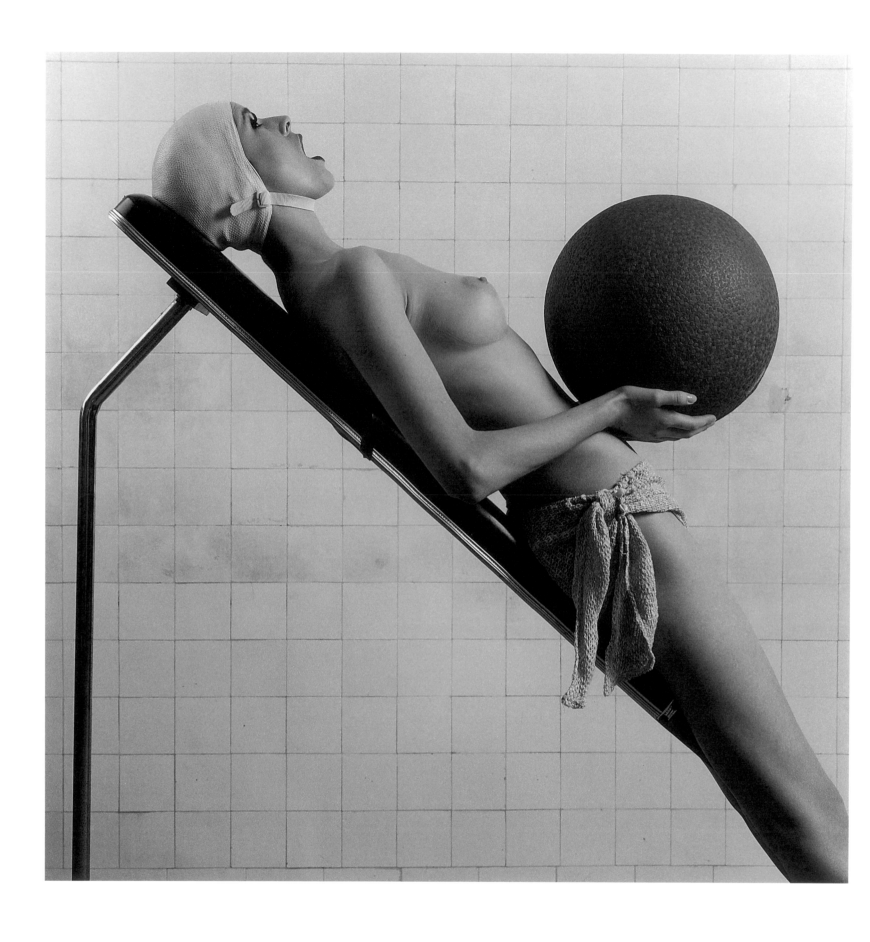

94

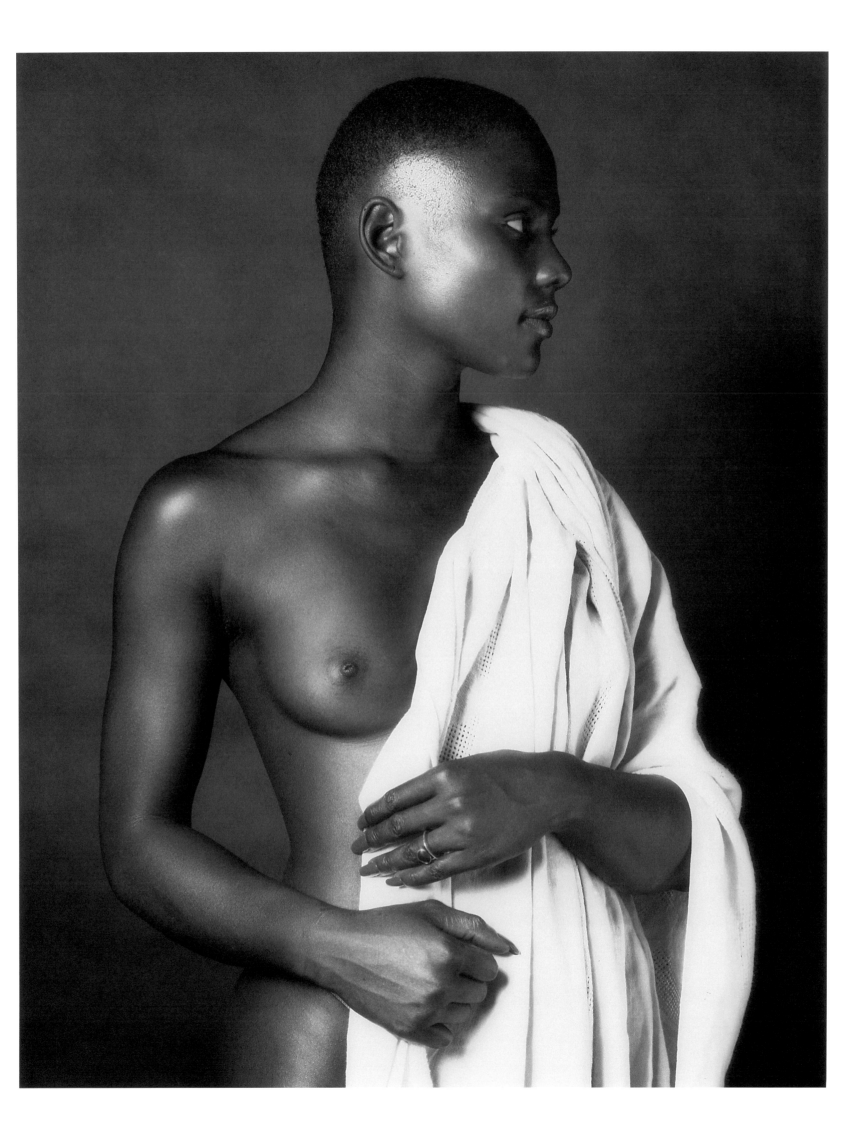

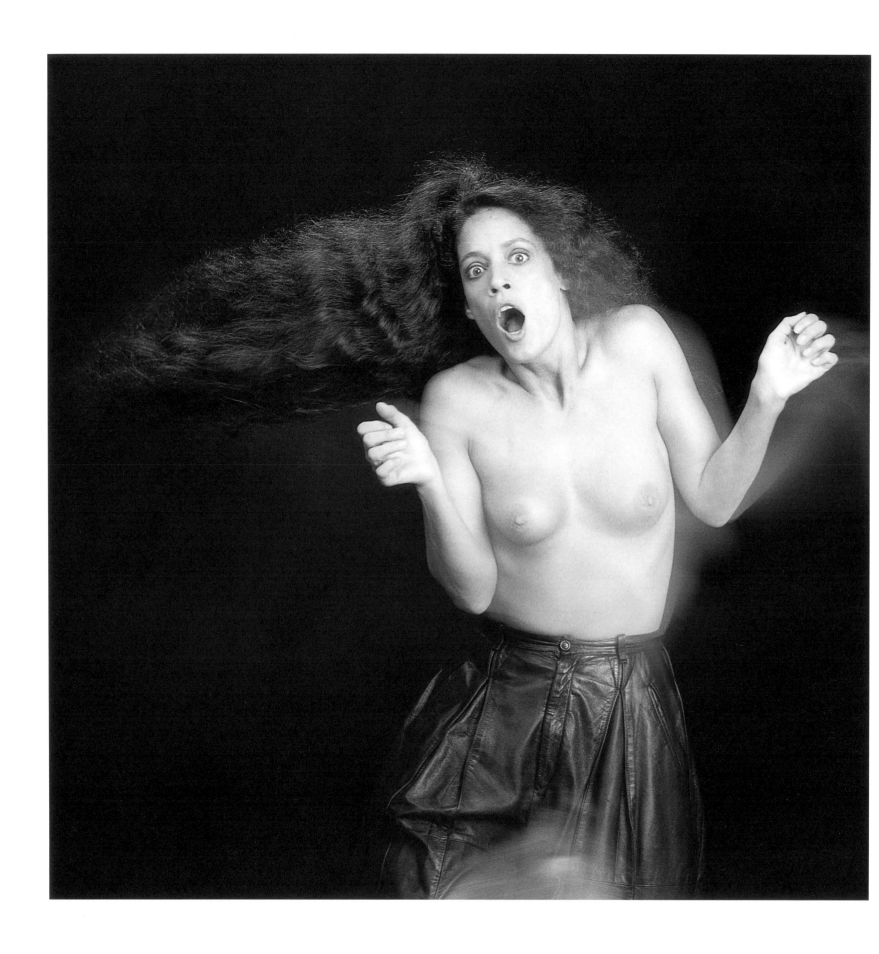

96

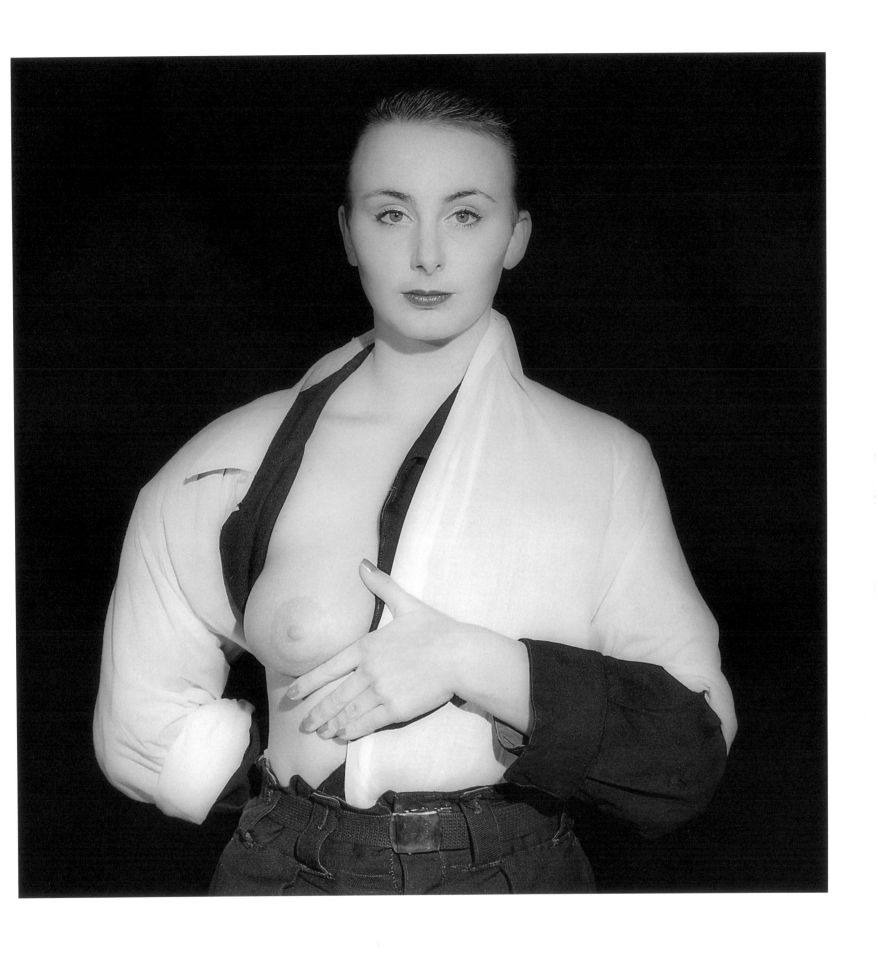

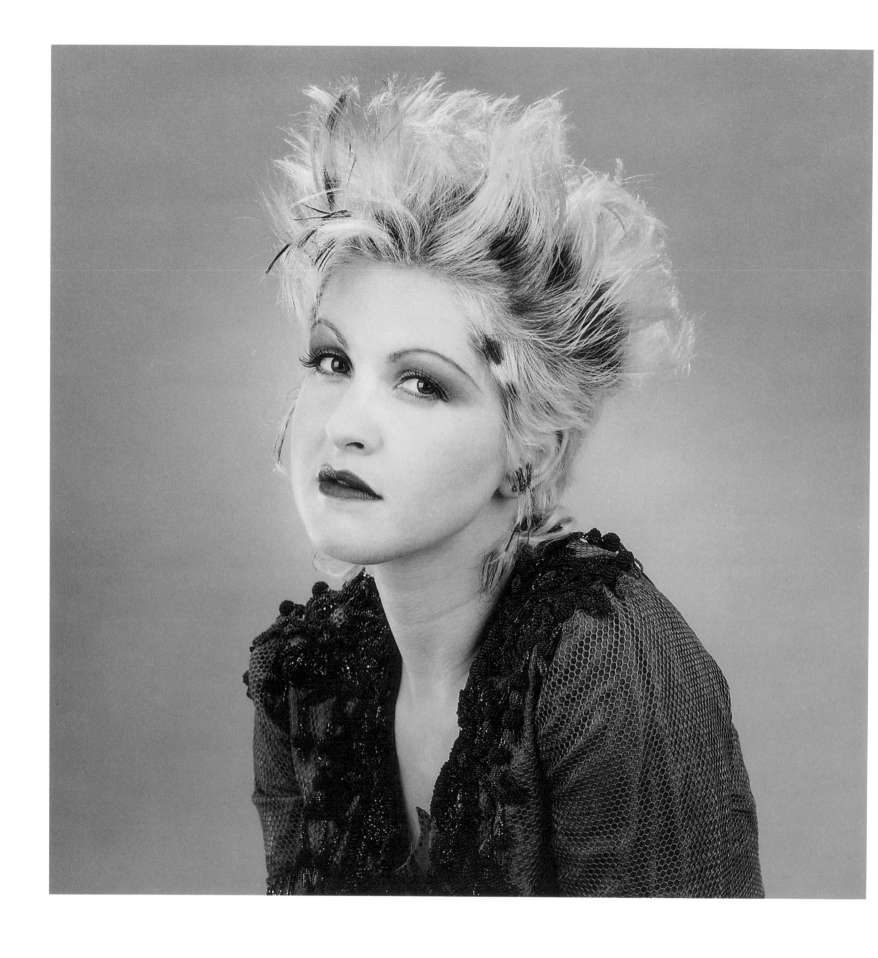

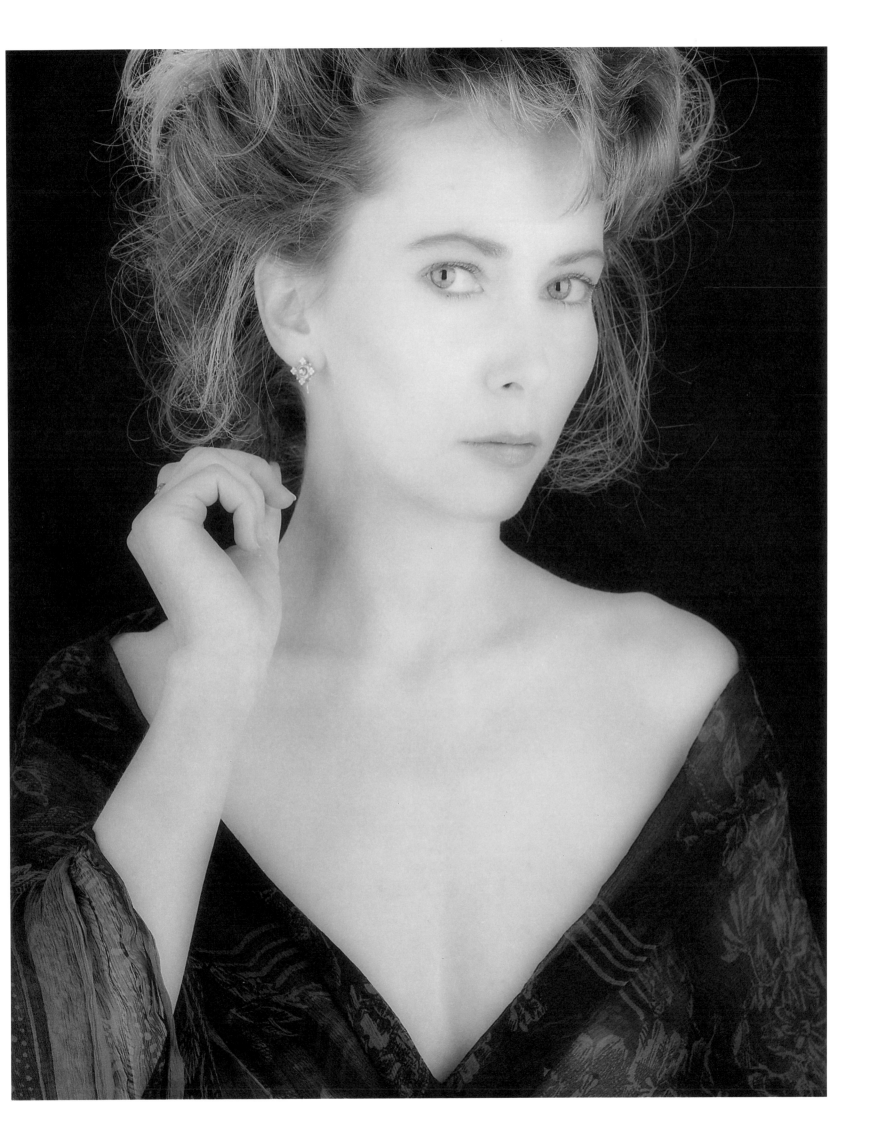

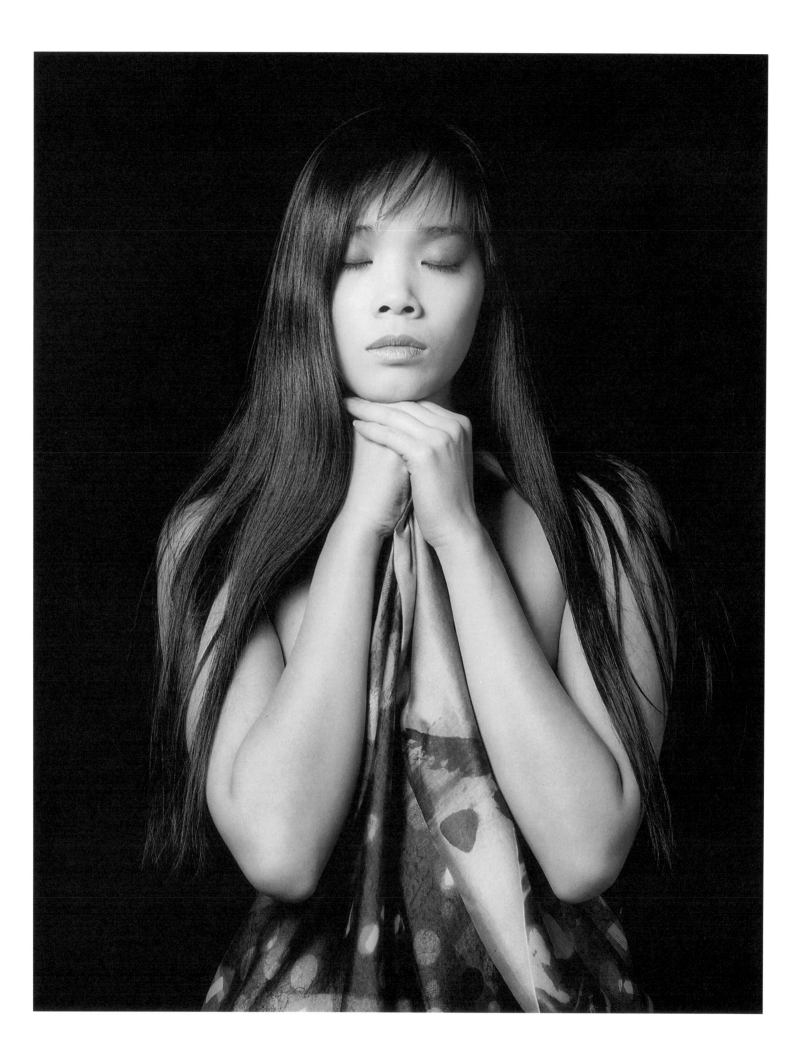

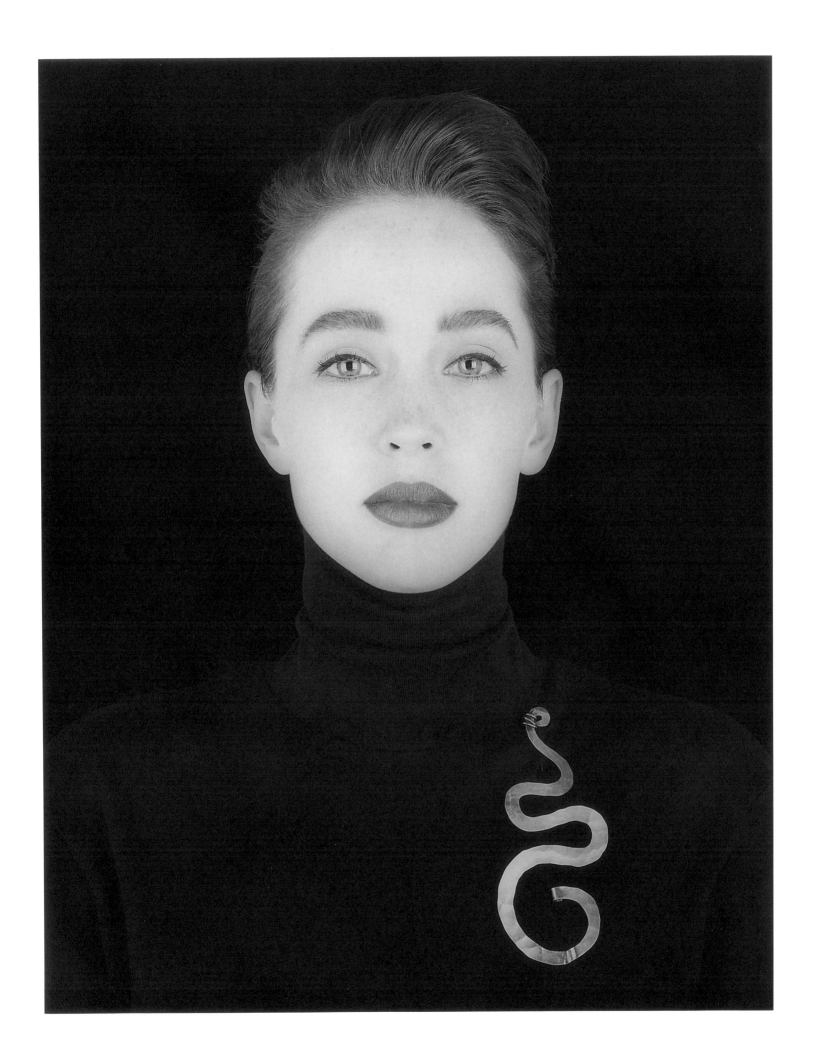

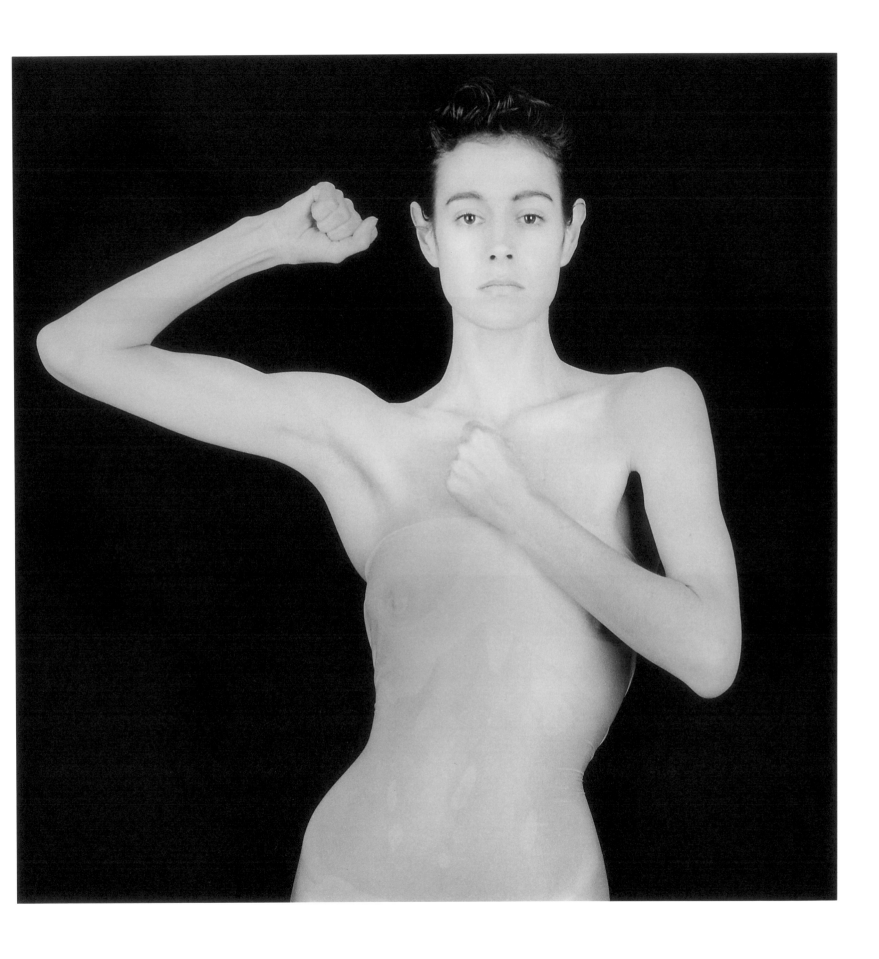

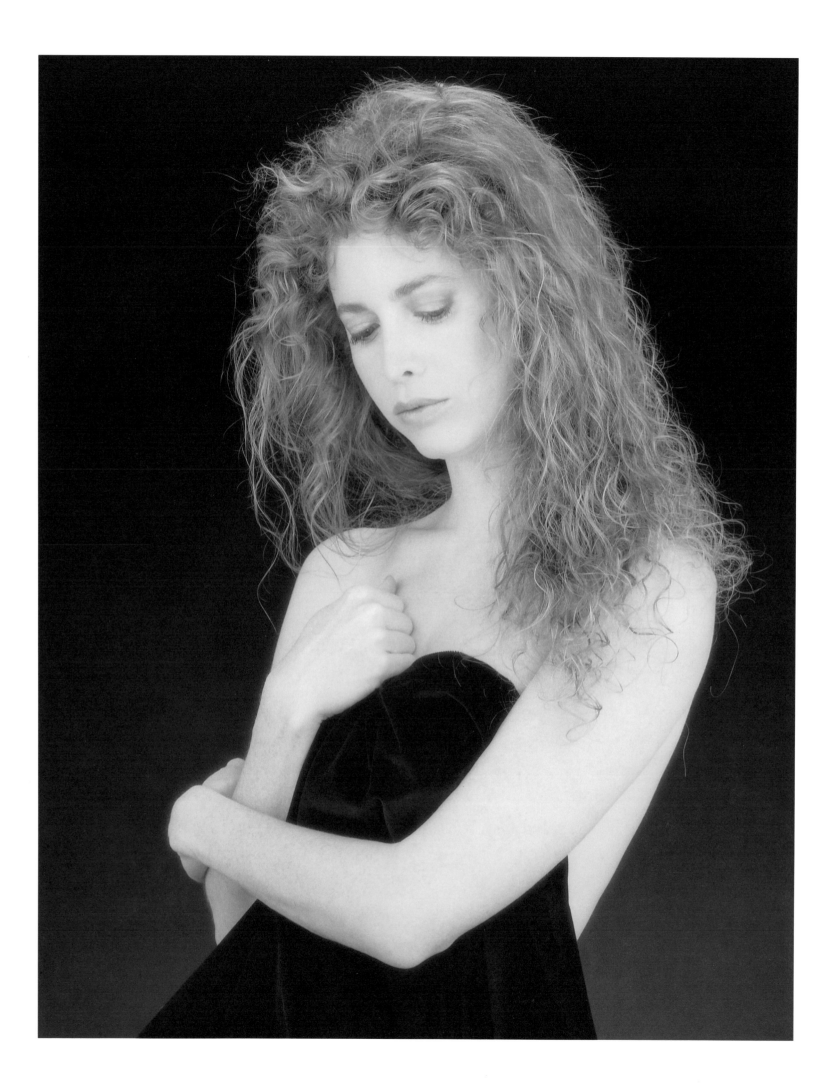

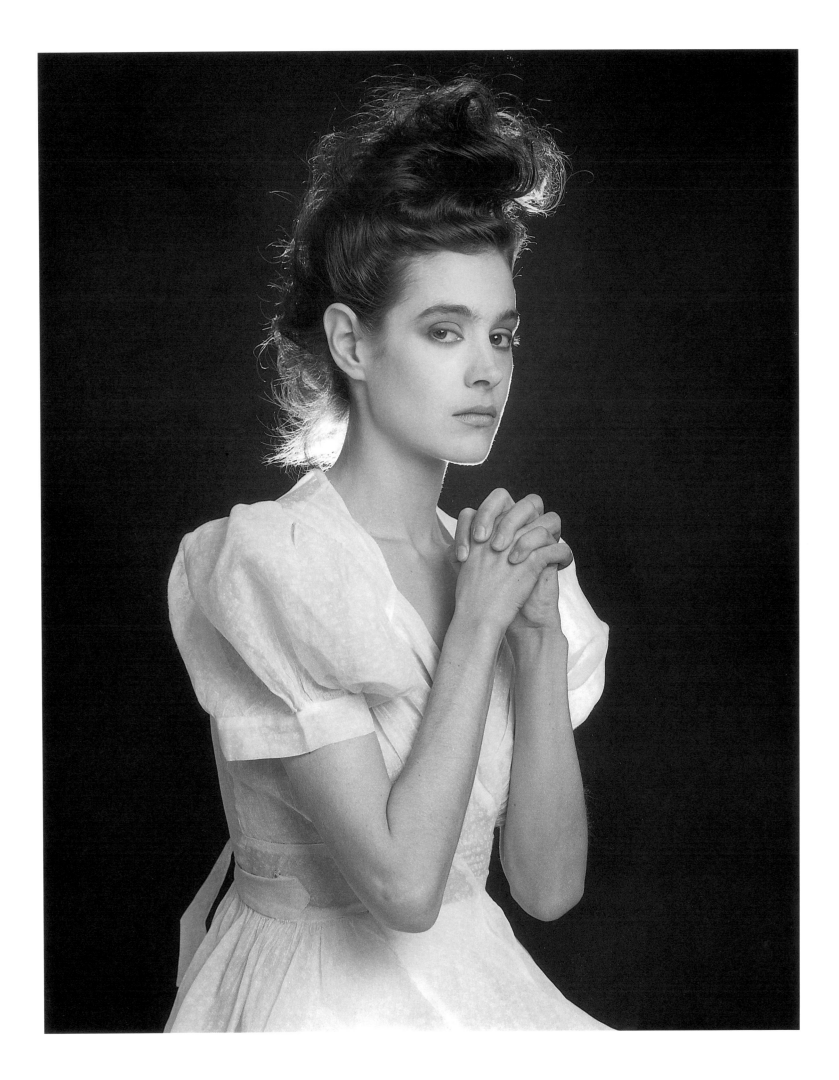

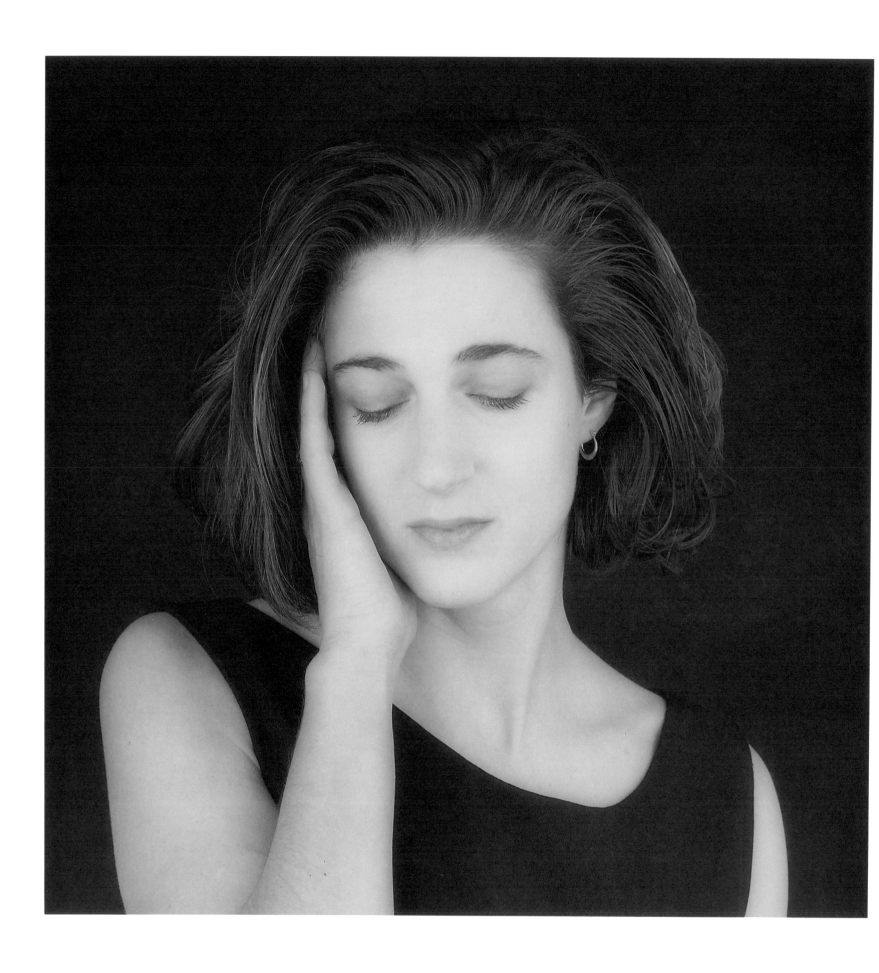

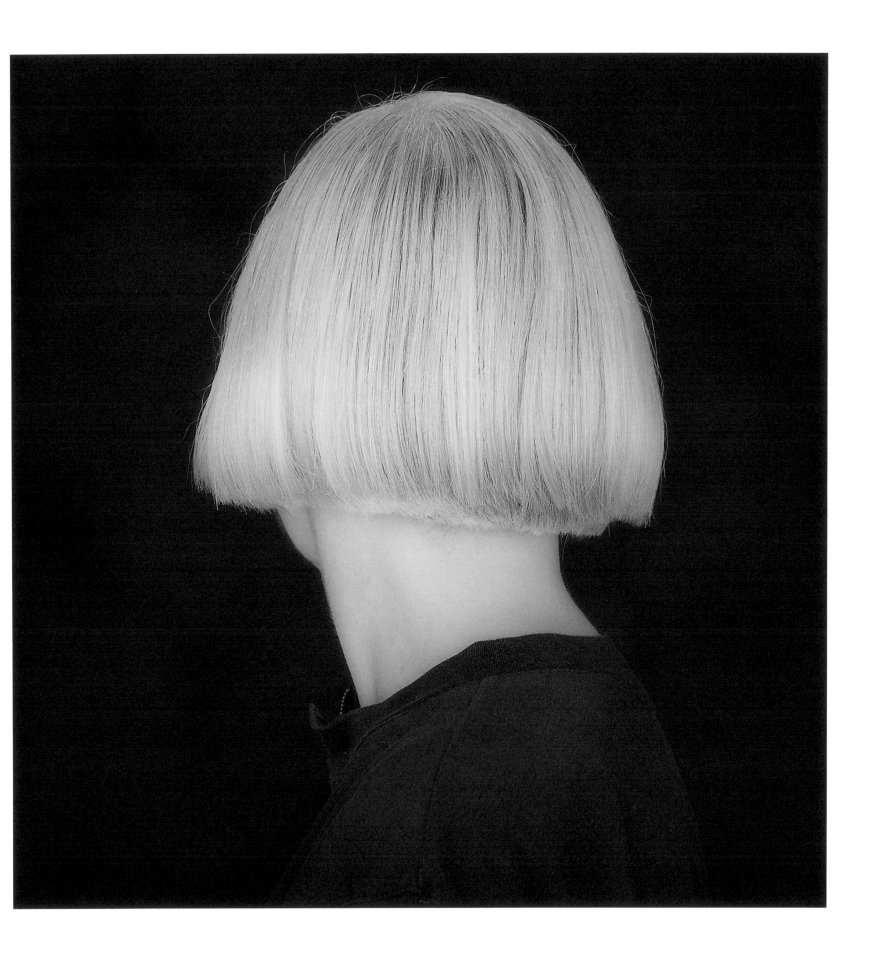

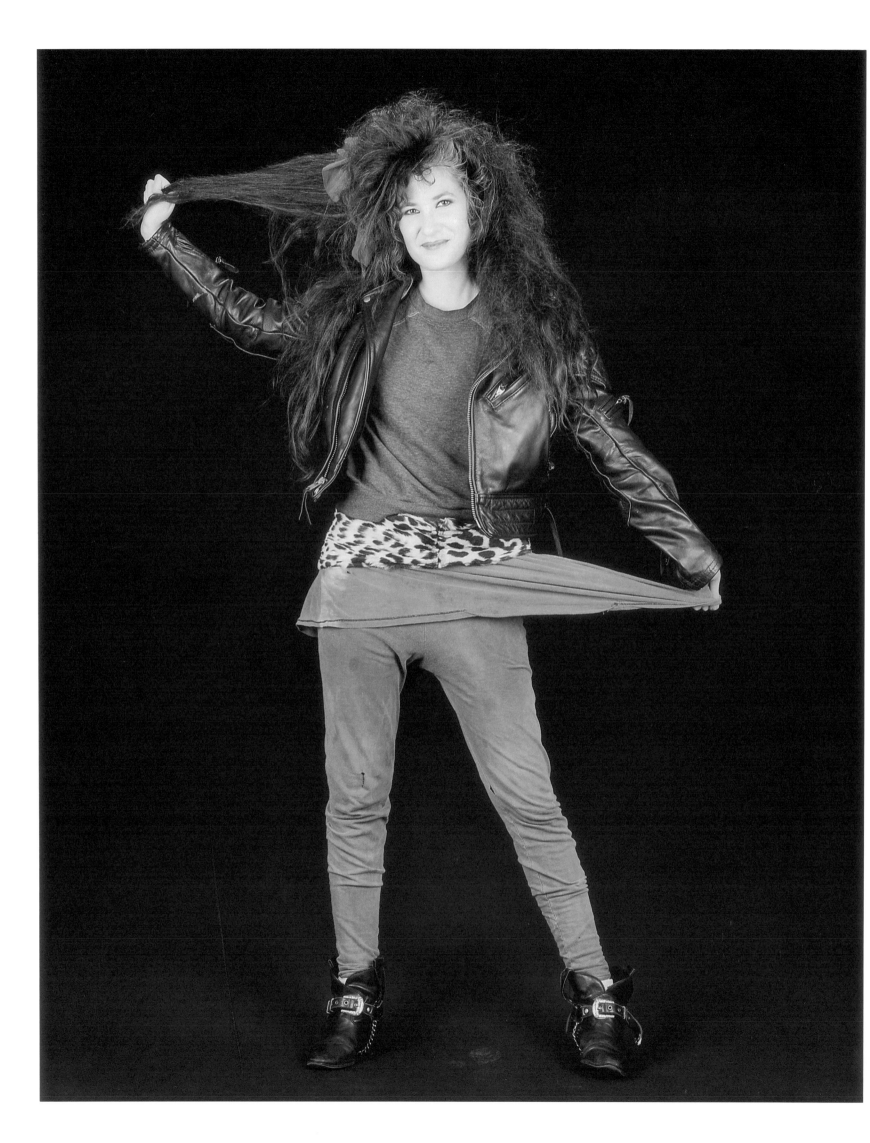

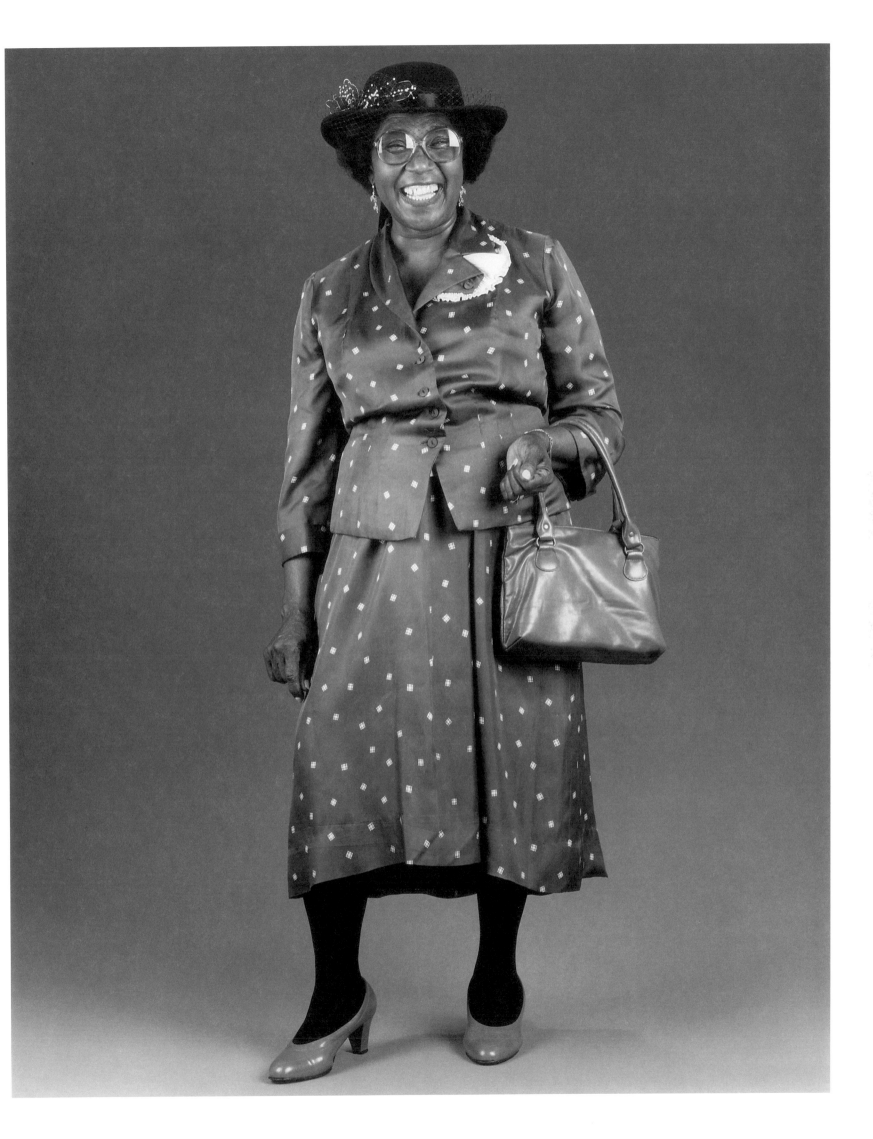

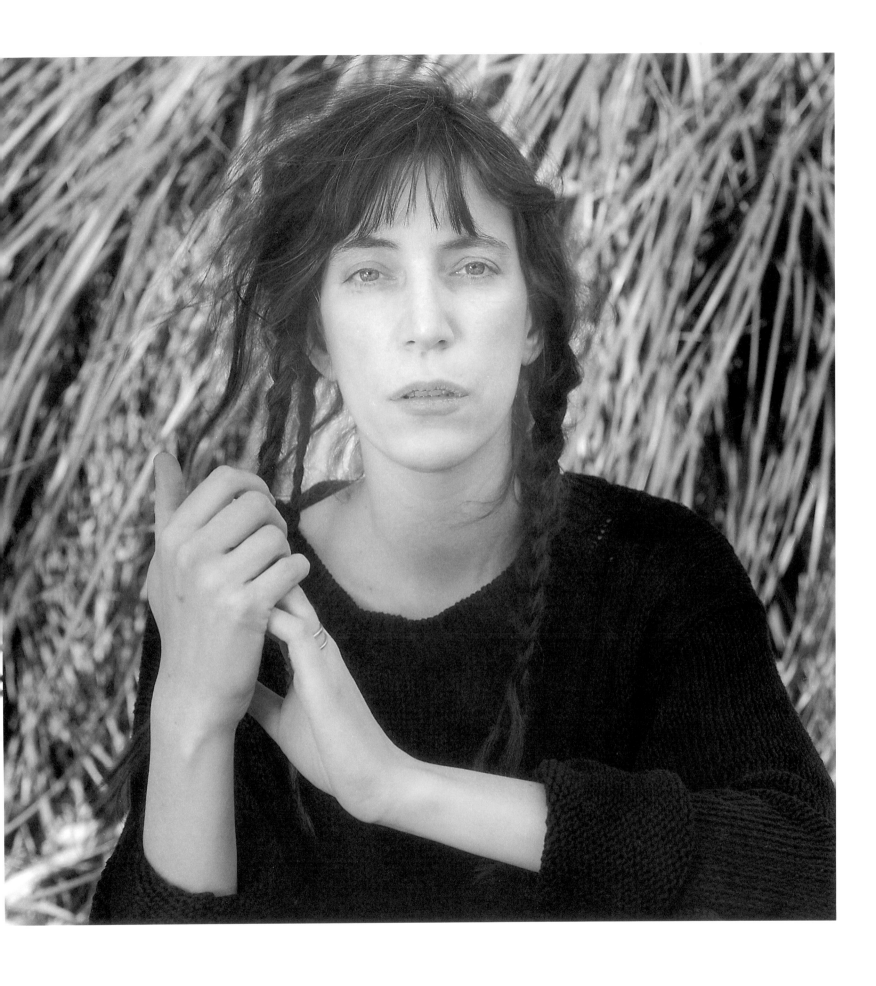

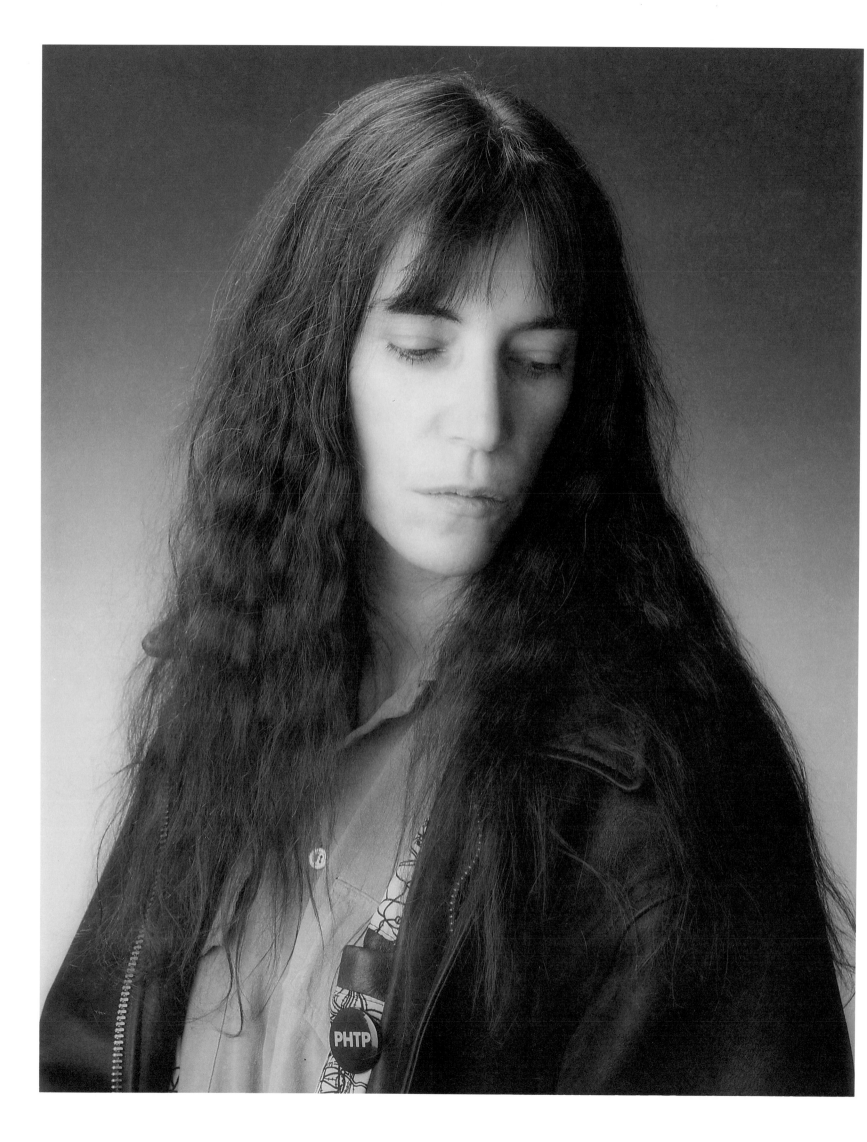

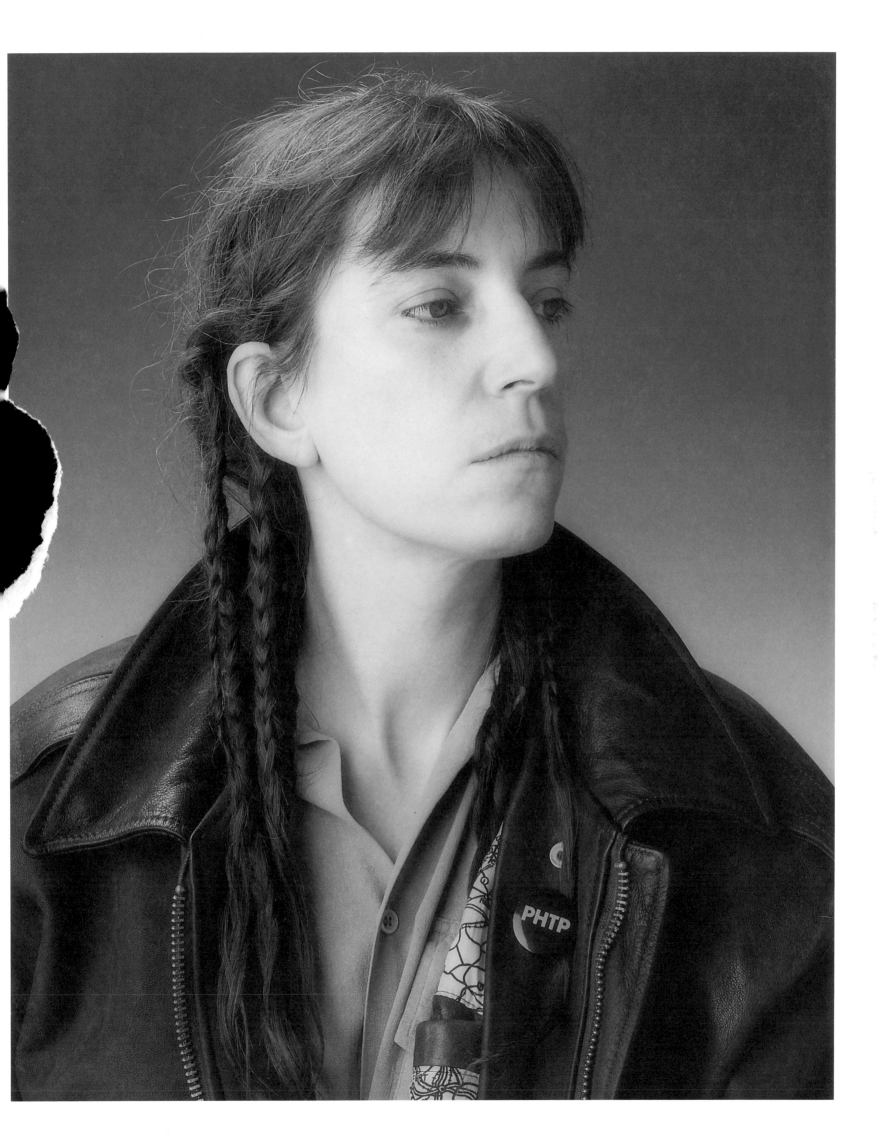

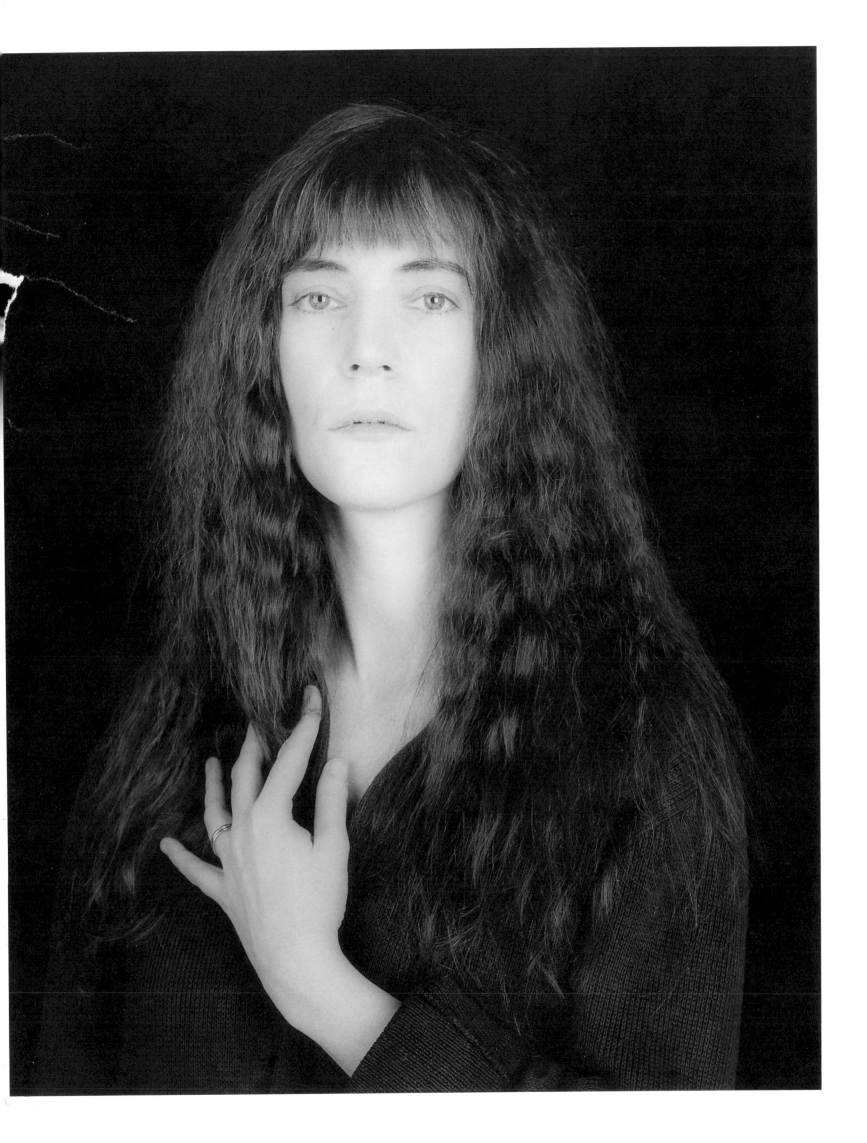

Plates

Special thanks to Art & Commerce, Tom Baril, Fern Buckner, Bob Carlson, Suzanne Donaldson, Brian English, Garcia, Jake, Alexandra Knaust, Dimitri Levas, Didier Malige, Bonnie Miller, Edward Maxey, Robert Miller Gallery, Mark Namias, John Sahag for Brooke Shields' hair, and Bill Westmoreland.

First edition 1986
First paperback edition 1992
Designed by Dimitri Levas

Some of these photographs have been previously published
in books by Robert Mapplethorpe and in catalogs of
exhibitions of his work.

Mapplethorpe, Robert.
 Some women / Robert Mapplethorpe; introduction by Joan Didion.—
1st ed.
 p. cm.
 ISBN 0-82122-1716-X (hc)
 ISBN 0-82122-1937-5 (pb)
 1. Photography of women. 2. Women—Portraits. 3. Mapplethorpe,
Robert. I. Title.
TR681.W6M363 1989
779'.24'092—dc20 89-31326
 CIP

Bulfinch Press is an imprint and trademark of
Little, Brown and Company (Inc.)

Published simultaneously in Canada by
Little, Brown & Company (Canada) Limited

Printed in the United States of America

Photograph selection and design by Dimitri Levas
Edited by Terry Reece Hackford
Production coordinated by Amanda Freymann
Printed by The Stinehour Press
on Mohawk Superfine
Bound by Mueller Trade Bindery